THE BONES OF US

YESYES BOOKS PORTLAND

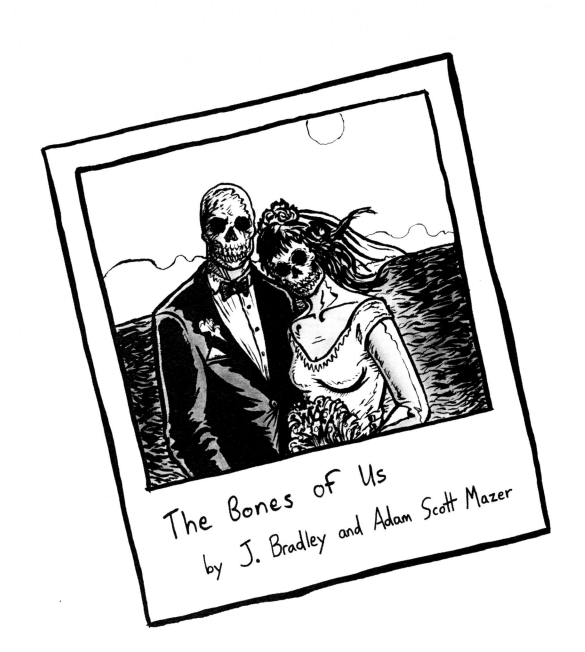

The Bones of Us
by J. Bradley and Adam Scott Mazer

CONTENTS

I

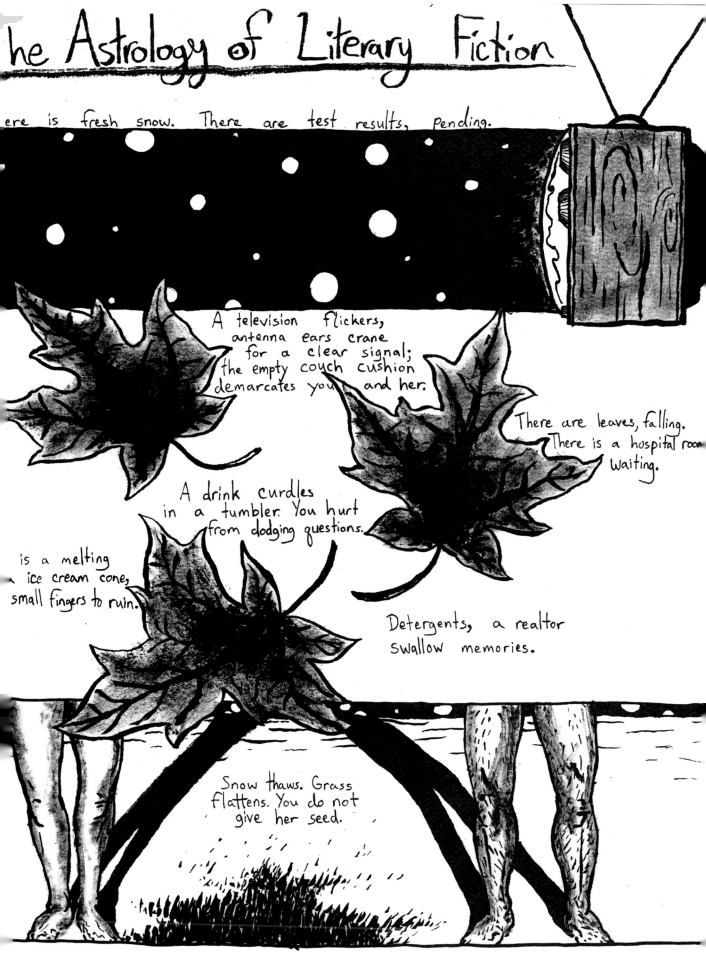

he Astrology of Literary Fiction

ere is fresh snow. There are test results, pending.

A television flickers,
antenna ears crane
for a clear signal;
the empty couch cushion
demarcates you and her.

There are leaves, falling.
There is a hospital room
waiting.

A drink curdles
in a tumbler. You hurt
from dodging questions.

is a melting
ice cream cone,
small fingers to ruin.

Detergents, a realtor
swallow memories.

Snow thaws. Grass
flattens. You do not
give her seed.

We Used to Vacation

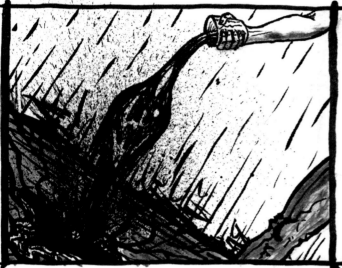

"Can you finish this for me?" You shove the scrap of your drink into my hands. We baptize the back corner of a parking lot before you pretend to be sober enough to drive.

Slits of sunlight slip through the blinds, rolling me face to face to you. Beneath your right eye, I see the crushed grape bruise. You rush to the bathroom where the tub gums the shower curtain.

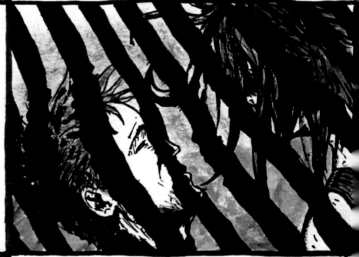

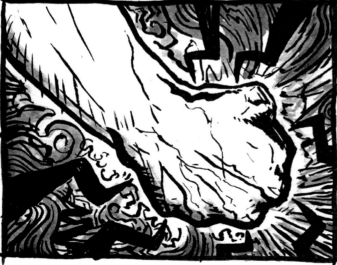

"Why haven't you touched me lately? Why haven't you fucked me?" I bleat, clenched fists are exclamation points after each question. Drunk depth perception makes six inches into three feet. I don't feel my thumb against your face.

Labor Day weekend, the failed winery long gone but you are a bottle with a message: goodbye. I try getting the kitchen sink bachelor party drunk. You spit yourself out the door. Two days later, your parents talk you back onto the ledge of your wedding ring.

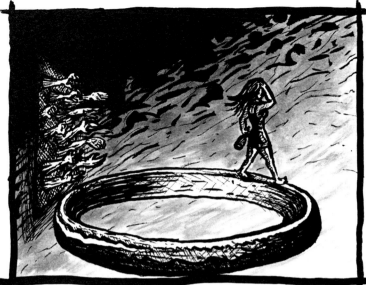

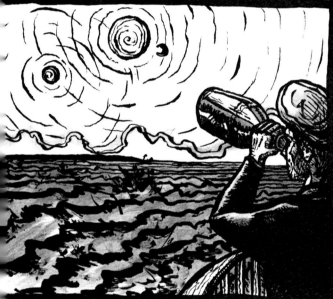

I don't mind that every woman at the party knows the taste of your lipstick. I am too busy pretending to captain yachts, looking for shore through empty wine bottles.

e are on a boat. The only rocking n our cabin is our stomachs nd hangovers. The moon, more rsenic than honey. Later, we rag about fucking over the hip when we snuck a bottle f rum made in Bayamon past ecurity after we re-boarded n San Juan.

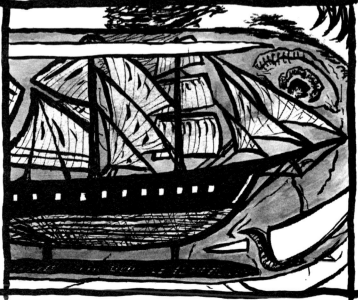

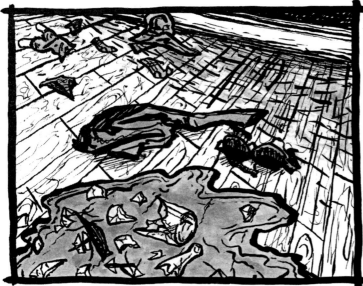

Two girls + me + my apartment + one large Jack & Coke = missing shirt, memory. The body raps against my teeth like floorboards. You throw the picture of us at the wall, the glass leaving enough space for my right knee to be around: I know I want to marry you then.

Around me, the men know how to hide the trophy of your lipstick.

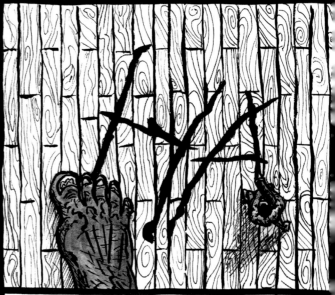

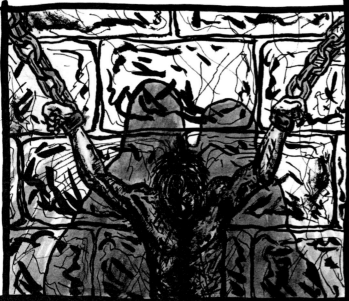

I hunt for other women so they can know what you taste like while I watch, lashed to something.

DETENTION

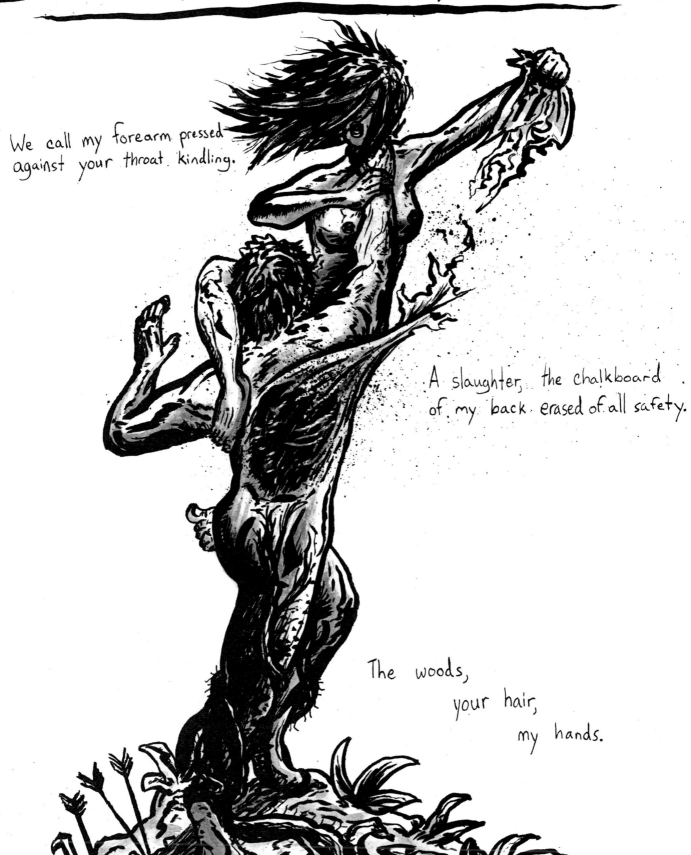

We call my forearm pressed against your throat, kindling.

A slaughter, the chalkboard of my back erased of all safety.

The woods,
your hair,
my hands.

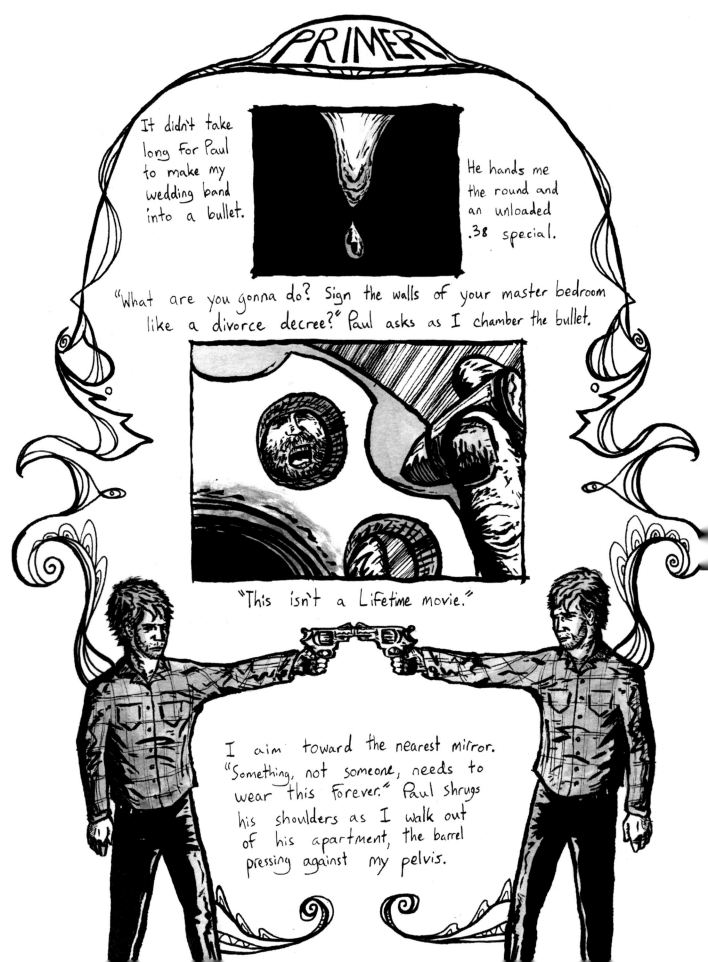

It didn't take long for Paul to make my wedding band into a bullet.

He hands me the round and an unloaded .38 special.

"What are you gonna do? Sign the walls of your master bedroom like a divorce decree?" Paul asks as I chamber the bullet.

"This isn't a Lifetime movie."

I aim toward the nearest mirror. "Something, not someone, needs to wear this forever." Paul shrugs his shoulders as I walk out of his apartment, the barrel pressing against my pelvis.

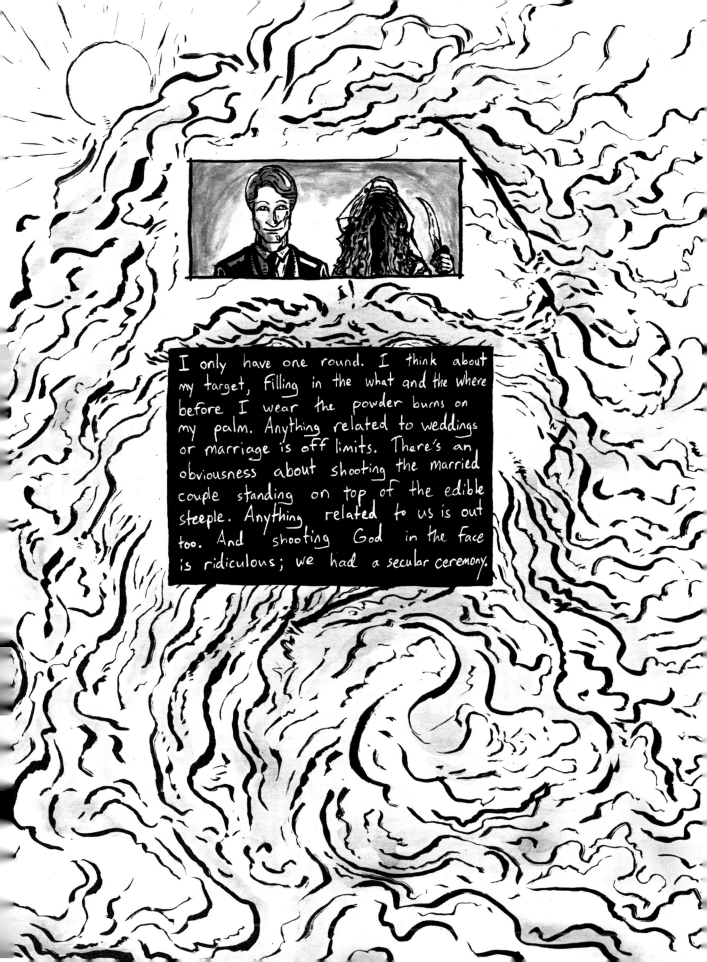

I only have one round. I think about my target, filling in the what and the where before I wear the powder burns on my palm. Anything related to weddings or marriage is off limits. There's an obviousness about shooting the married couple standing on top of the edible steeple. Anything related to us is out too. And shooting God in the face is ridiculous; we had a secular ceremony.

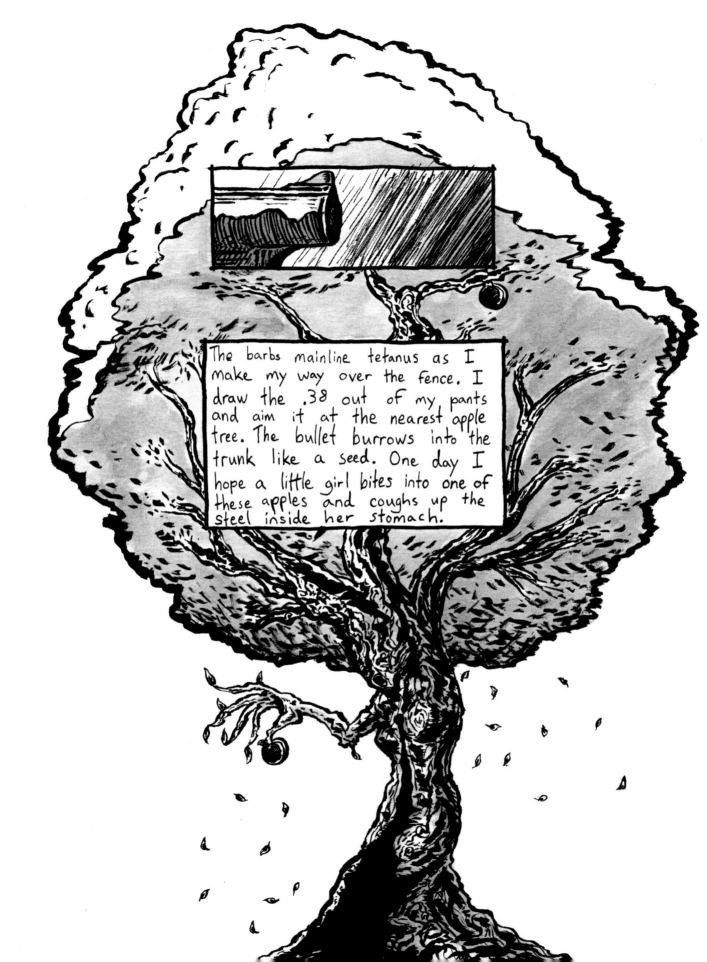

KNIFE SHOW

When I show you how I melted my wedding band into a bullet you say you like the direction my art is heading.

I wish I could see thumb prints smudging your glassy eyes, find all the mouths you abandoned.

My art was a magnet to your moral compass. You were a knife show sheathed in Victoria's Secret.

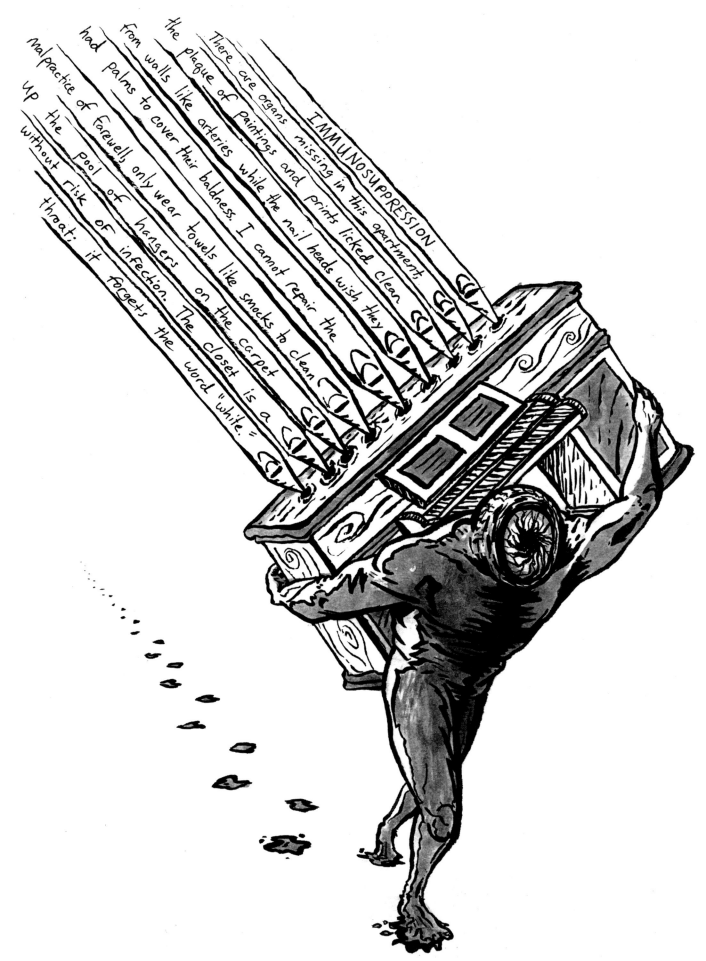

IMMUNOSUPPRESSION

There are organs missing in this apartment, the plaque of paintings and prints licked clean from walls like arteries while the nail heads wish they had palms to cover their baldness. I cannot repair the hangers on the carpet only wear towels like smocks to clean up the pool of farewells without risk of infection. The closet is a throat; it forgets the word "white."

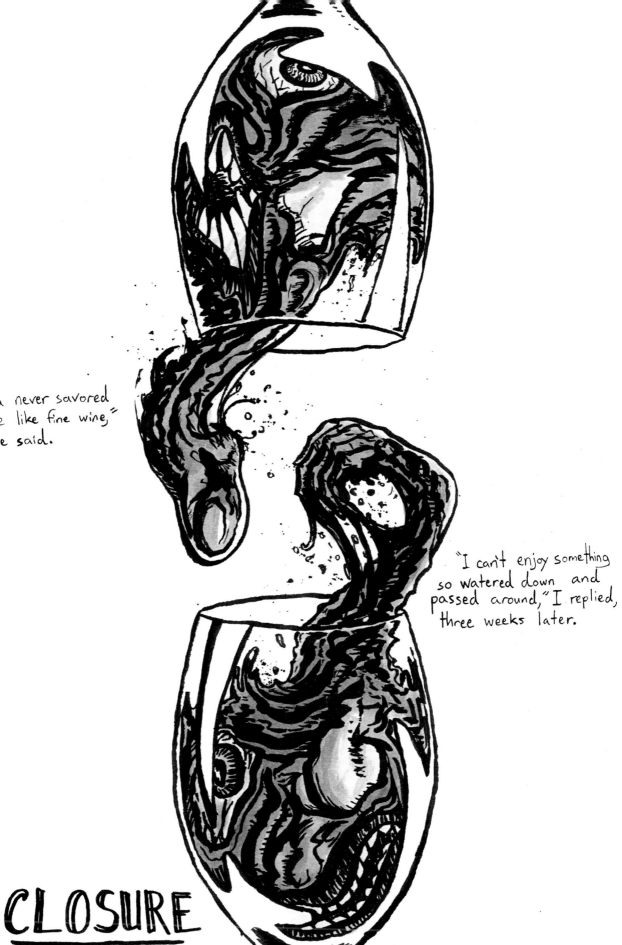

"You never savored me like fine wine," she said.

"I can't enjoy something so watered down and passed around," I replied, three weeks later.

CLOSURE

The Ghost Staring At You Is Your Ex-Wife's New Girlfriend

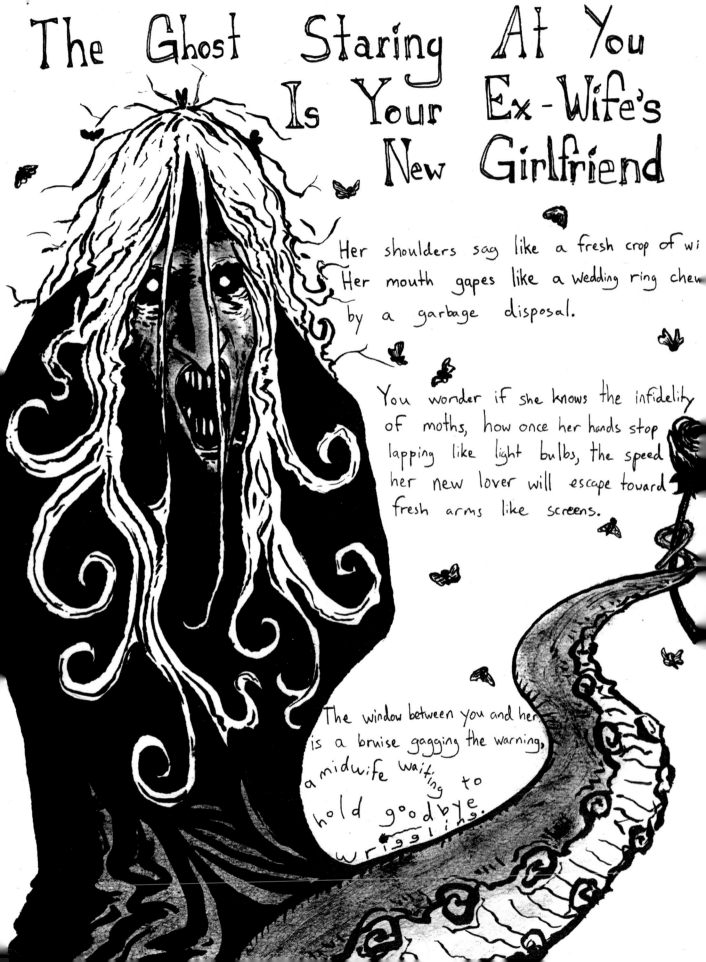

Her shoulders sag like a fresh crop of wi
Her mouth gapes like a wedding ring chew
by a garbage disposal.

You wonder if she knows the infidelity
of moths, how once her hands stop
lapping like light bulbs, the speed
her new lover will escape toward
fresh arms like screens.

The window between you and her
is a bruise gagging the warning,
a midwife waiting to
hold goodbye
wriggling.

Are We The Dining Dead?

The elderly couple sitting three booths away from us cuts through the piped in music.

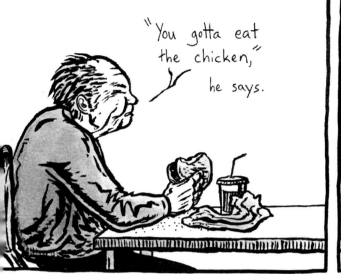

"You gotta eat the chicken," he says.

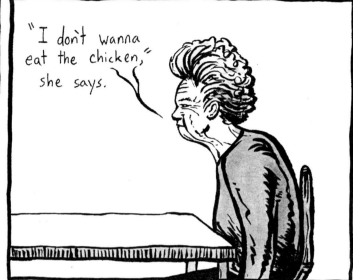

"I don't wanna eat the chicken," she says.

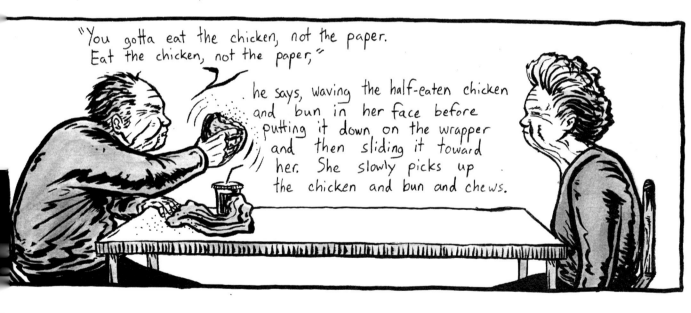

"You gotta eat the chicken, not the paper. Eat the chicken, not the paper," he says, waving the half-eaten chicken and bun in her face before putting it down on the wrapper and then sliding it toward her. She slowly picks up the chicken and bun and chews.

You say, "I hope when we get that old, you'll make me eat the chicken."

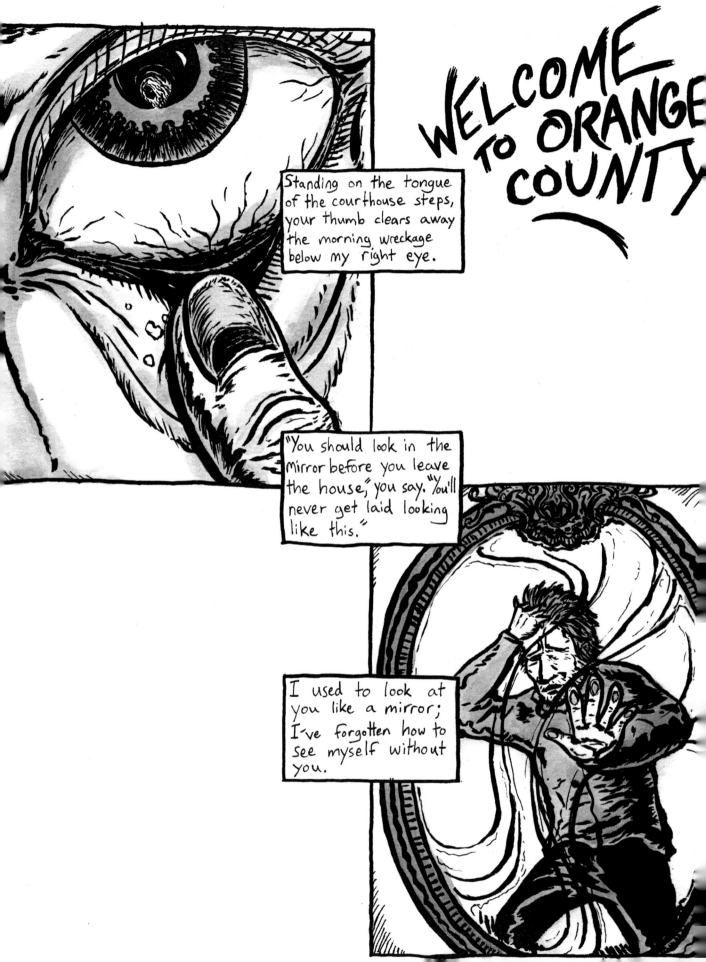

REVISION

first letter of your name sleeps below my wrist;
I'm not sure what to smother it with.

e no solution symbol
th the diagonal line
npaling the stem
es for an awkward
autionary tale.

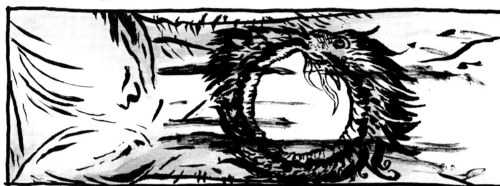

e no quarter flag
d be a lie; I swallowed
ything I should have said
hen you splintered
ke a confessional.

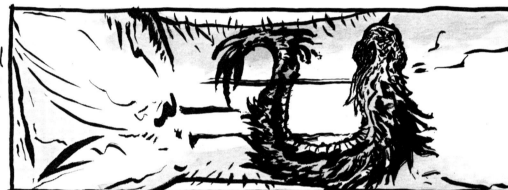

vin pissing into larger
rsive oval of the J
would be rude
d hard to explain.

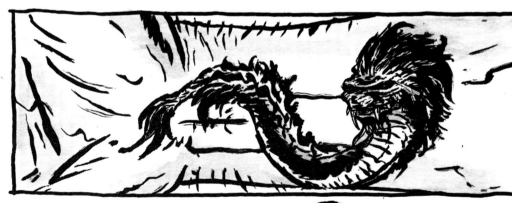

en I tell my lovers
s where you once lived,
their right hand knows
re to hold me down
you can't watch.

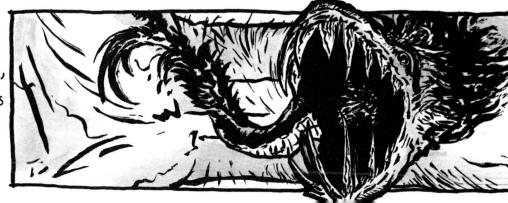

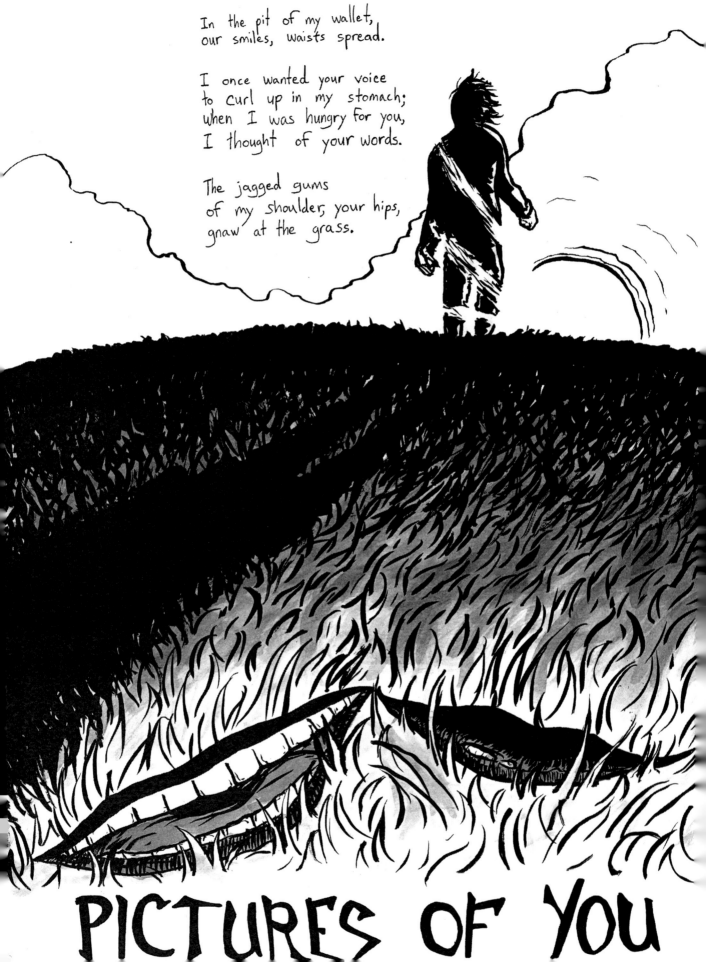

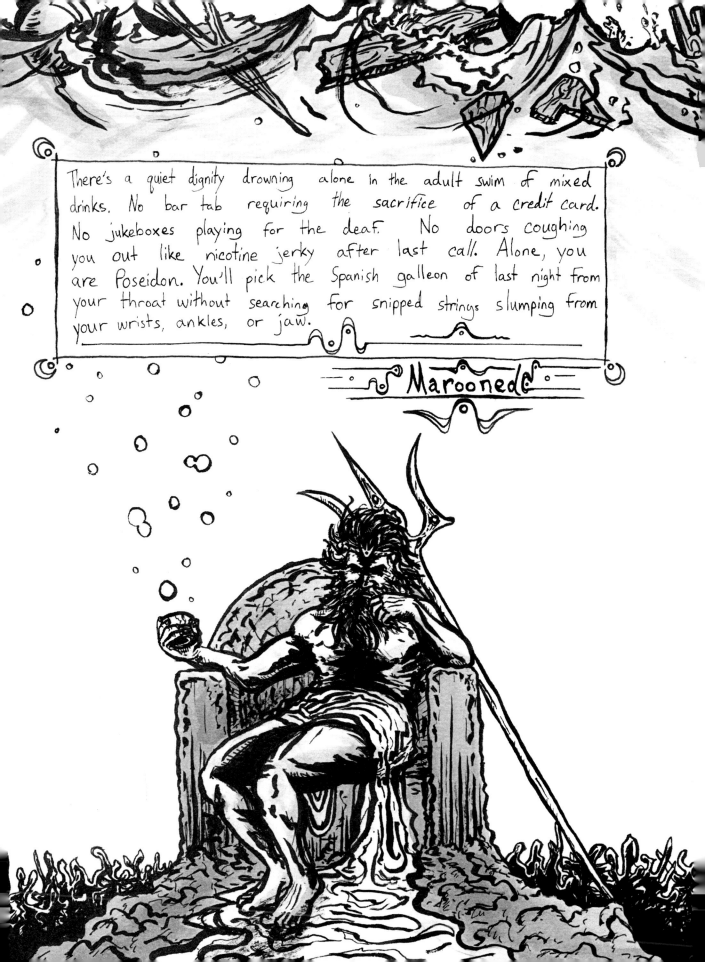

There's a quiet dignity drowning alone in the adult swim of mixed drinks. No bar tab requiring the sacrifice of a credit card. No jukeboxes playing for the deaf. No doors coughing you out like nicotine jerky after last call. Alone, you are Poseidon. You'll pick the Spanish galleon of last night from your throat without searching for snipped strings slumping from your wrists, ankles, or jaw.

Marooned

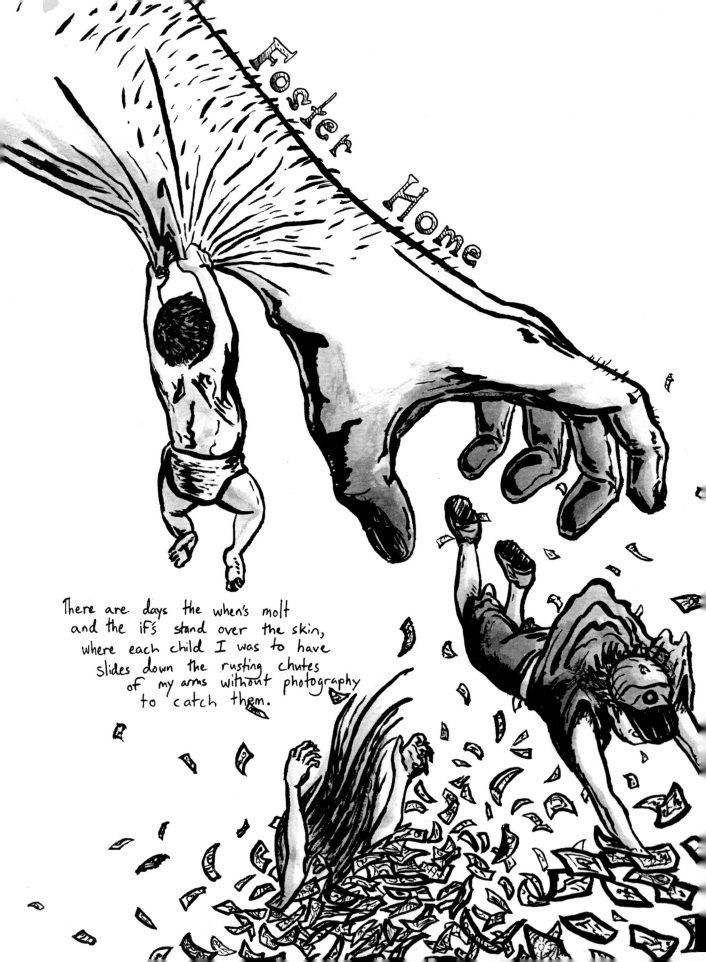

Foster Home

There are days the when's molt
and the if's stand over the skin,
where each child I was to have
slides down the rusting chutes
of my arms without photography
to catch them.

Parabolic

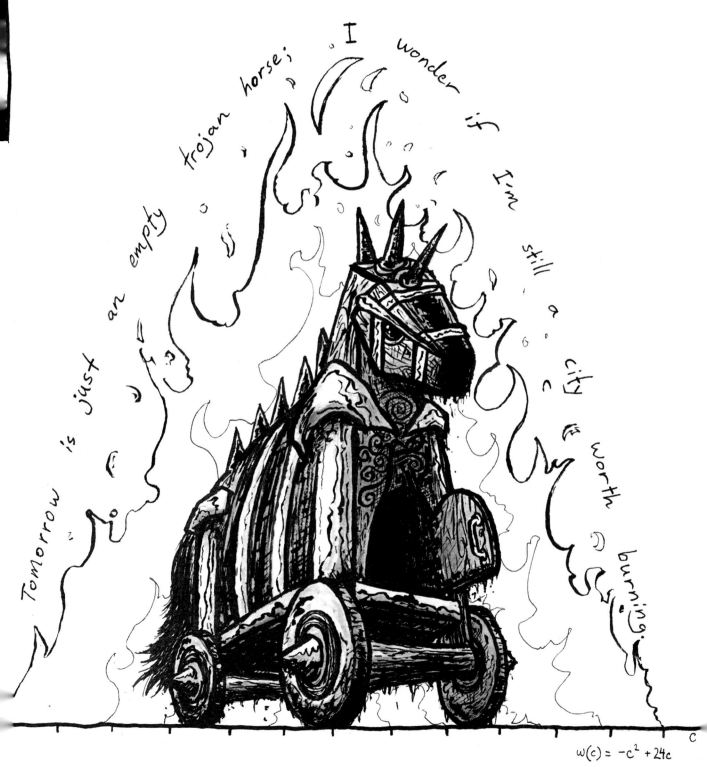

Tomorrow is just an empty trojan horse; I wonder if I'm still a city worth burning.

$$w(c) = -c^2 + 24c$$

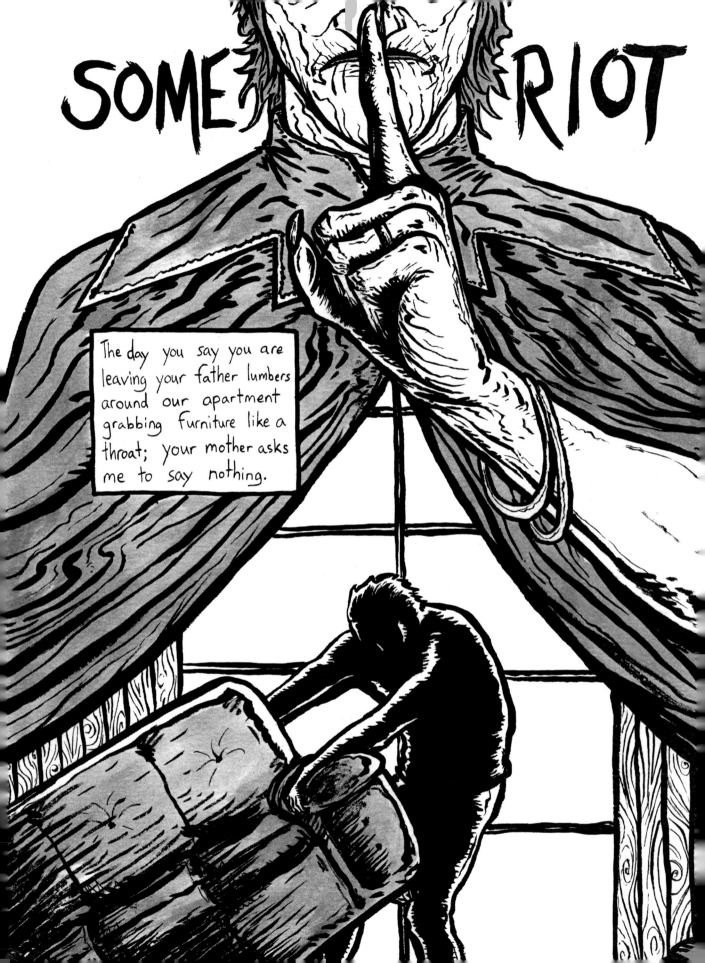

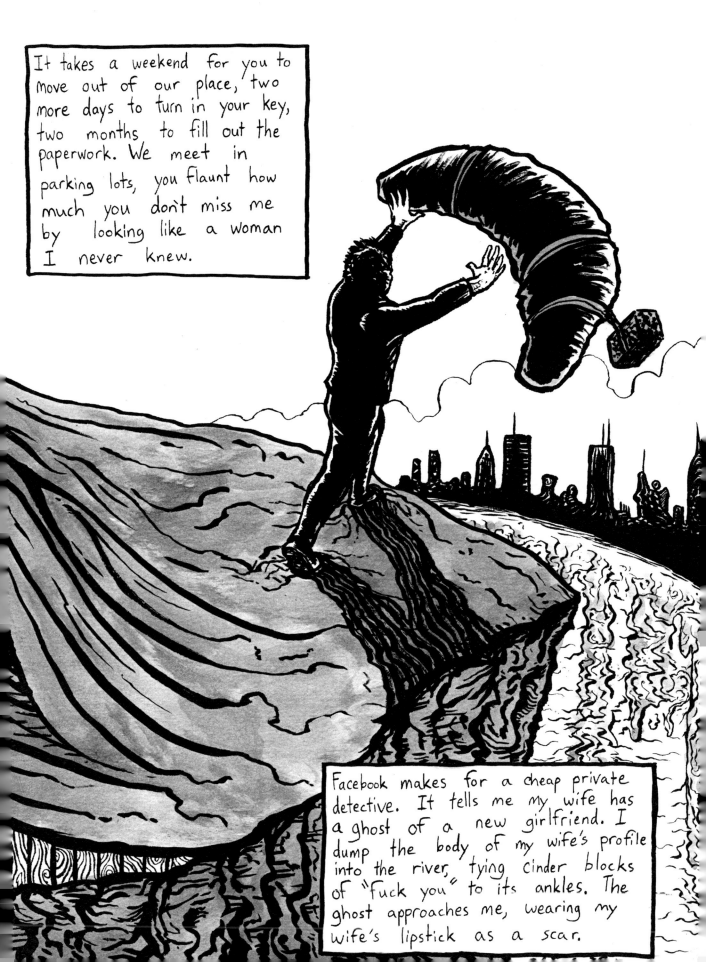

It takes a weekend for you to move out of our place, two more days to turn in your key, two months to fill out the paperwork. We meet in parking lots, you flaunt how much you don't miss me by looking like a woman I never knew.

Facebook makes for a cheap private detective. It tells me my wife has a ghost of a new girlfriend. I dump the body of my wife's profile into the river, tying cinder blocks of "fuck you" to its ankles. The ghost approaches me, wearing my wife's lipstick as a scar.

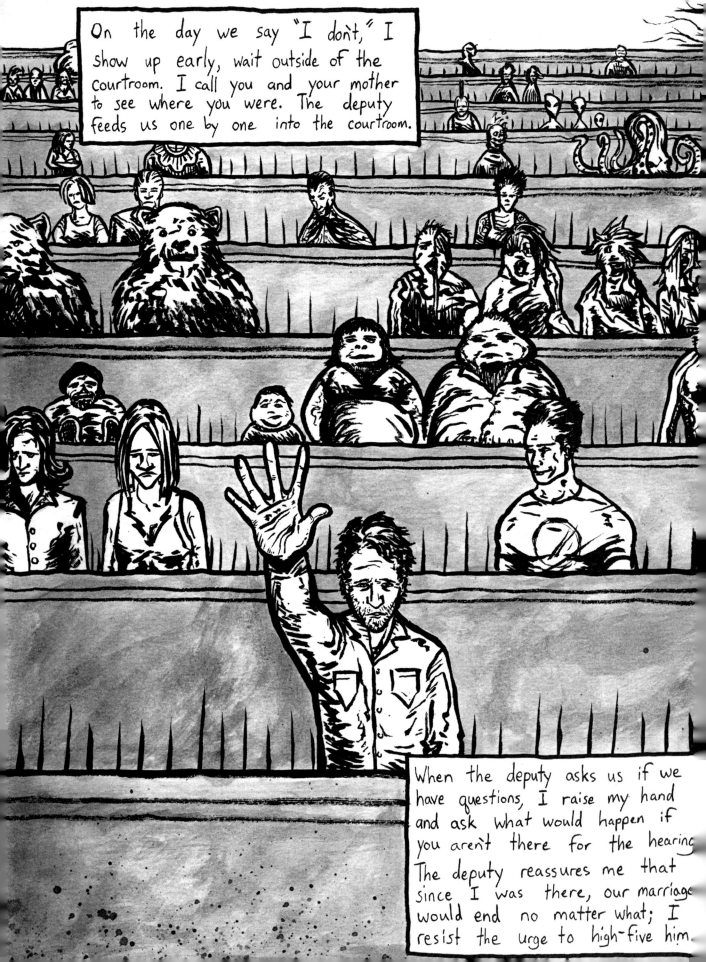

On the day we say "I don't," I show up early, wait outside of the courtroom. I call you and your mother to see where you were. The deputy feeds us one by one into the courtroom.

When the deputy asks us if we have questions, I raise my hand and ask what would happen if you aren't there for the hearing. The deputy reassures me that since I was there, our marriage would end no matter what; I resist the urge to high-five him.

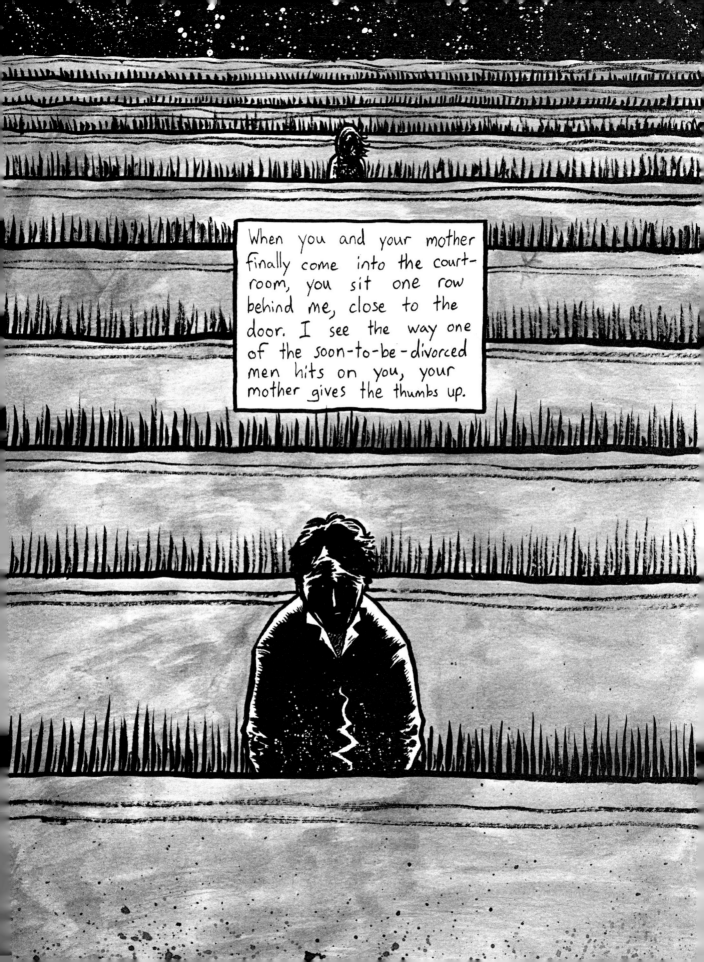

II

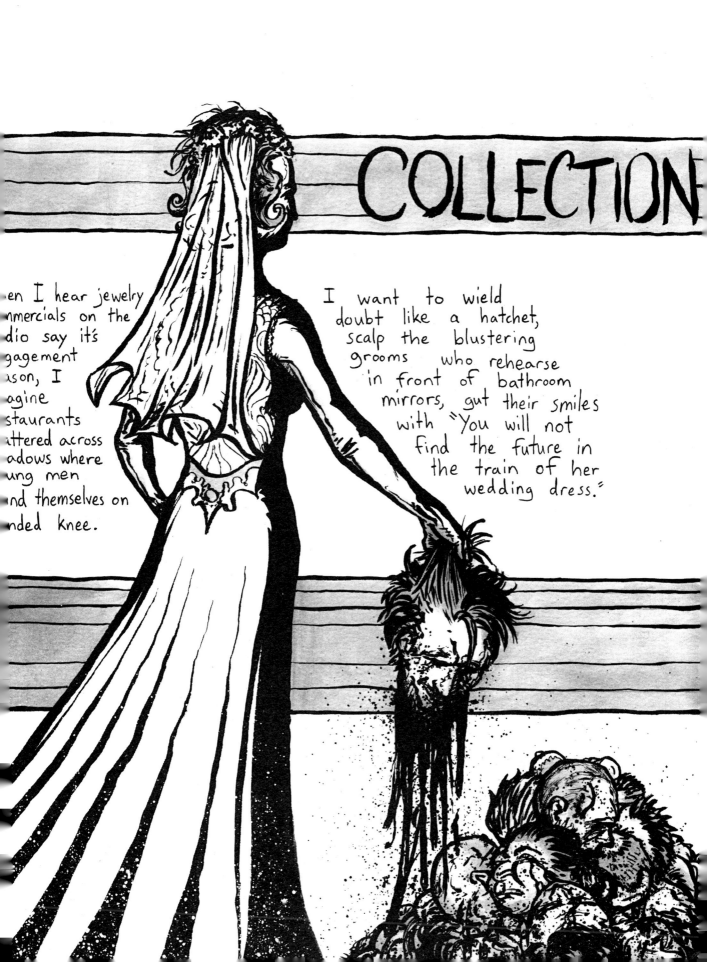

COLLECTION

en I hear jewelry
nmercials on the
dio say it's
gagement
ason, I
agine
staurants
ittered across
adows where
ung men
nd themselves on
nded knee.

I want to wield
doubt like a hatchet,
scalp the blustering
grooms who rehearse
in front of bathroom
mirrors, gut their smiles
with "You will not
find the future in
the train of her
wedding dress."

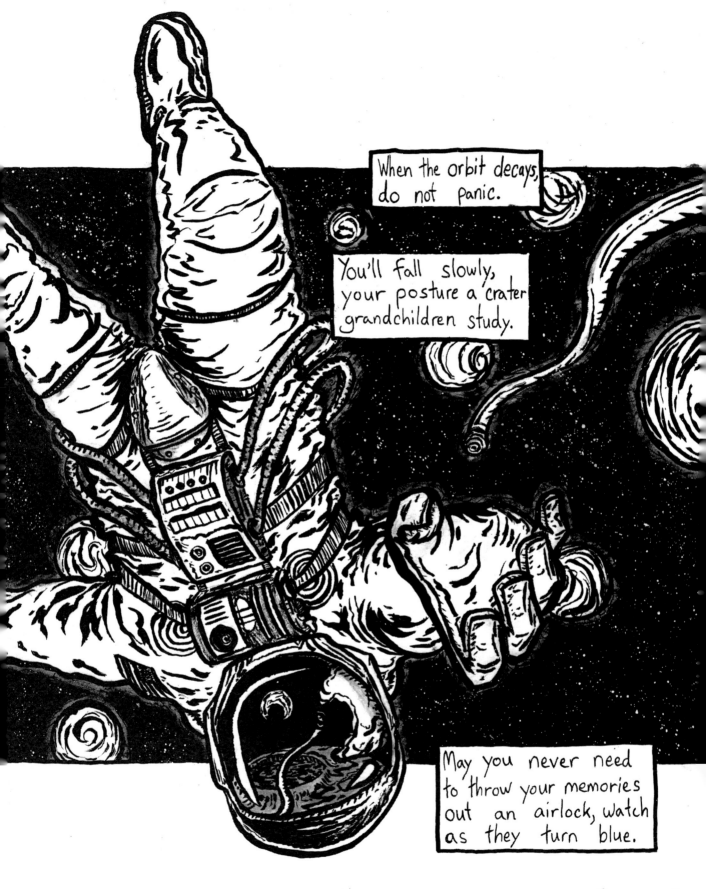

A Letter to a Wedding Photo That's Not Mi

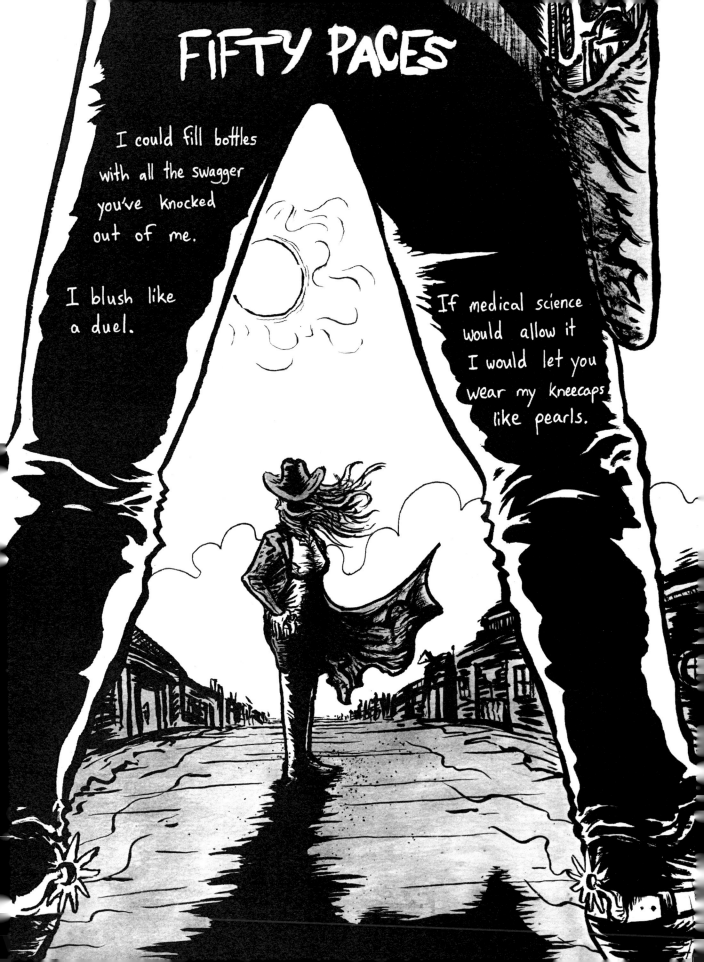

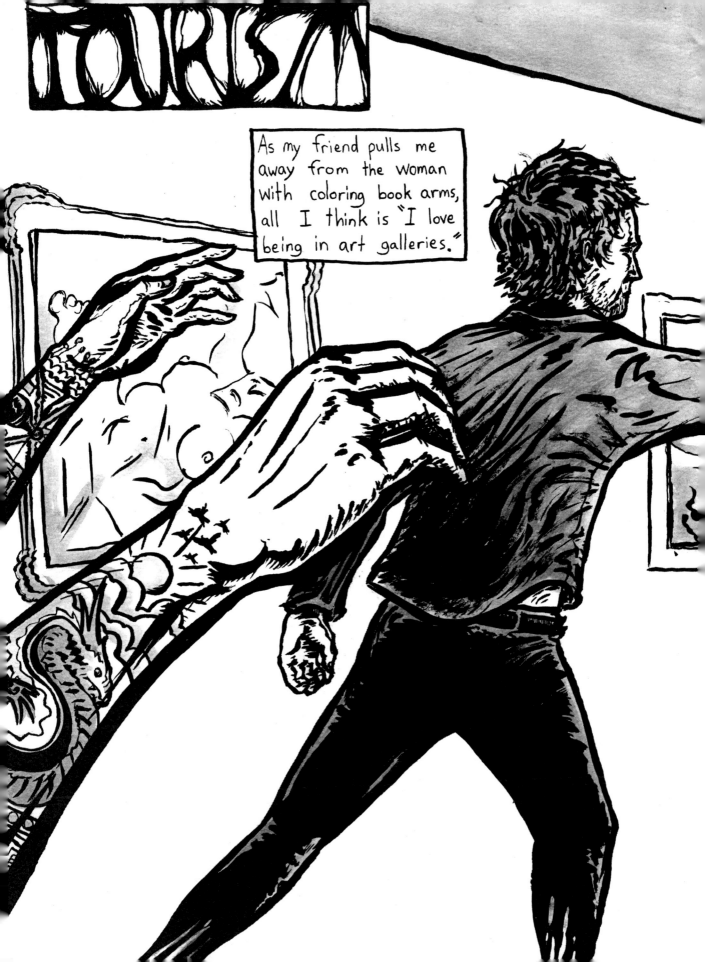

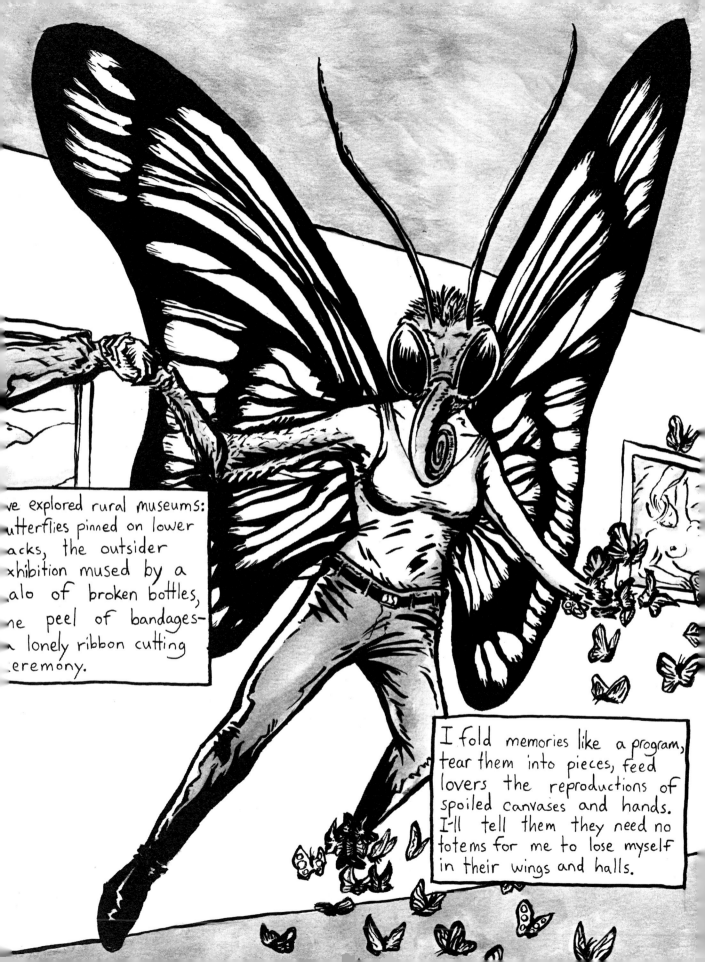

ve explored rural museums:
utterflies pinned on lower
acks, the outsider
xhibition mused by a
alo of broken bottles,
ne peel of bandages—
 lonely ribbon cutting
eremony.

I fold memories like a program,
tear them into pieces, feed
lovers the reproductions of
spoiled canvases and hands.
I'll tell them they need no
totems for me to lose myself
in their wings and halls.

There is a mountain range
of freckles on your shoulders;
I want to lose my fingers in them
like a body.

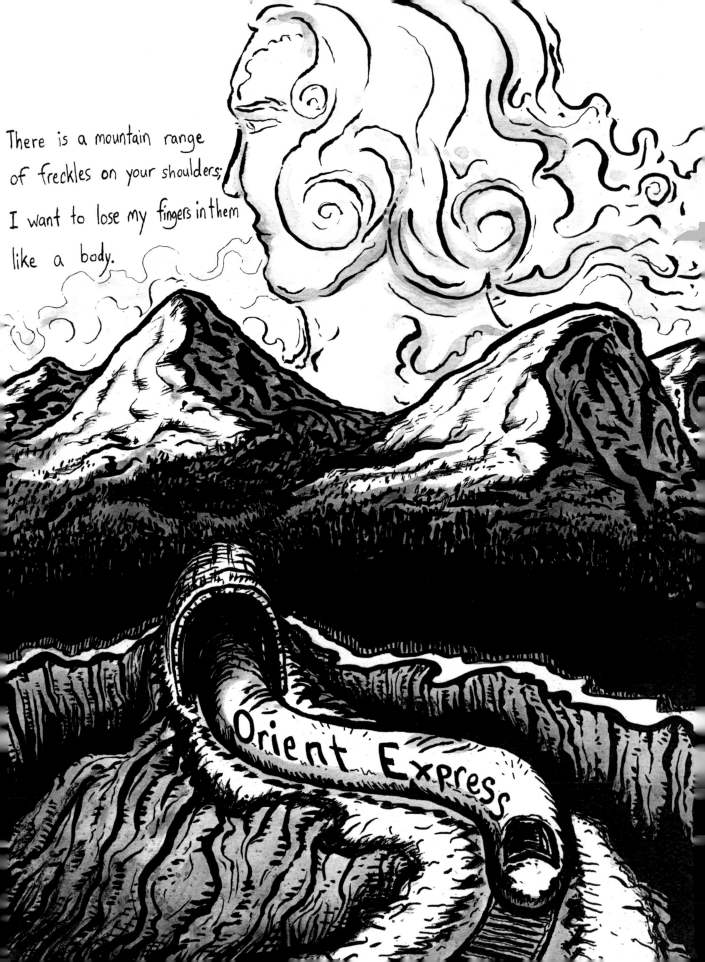

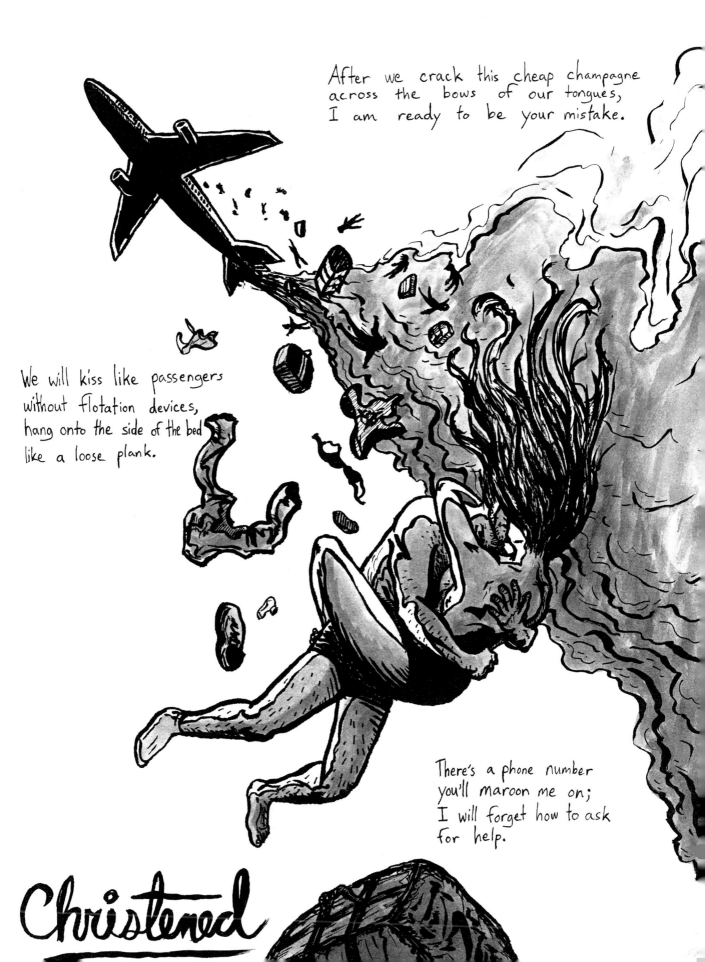

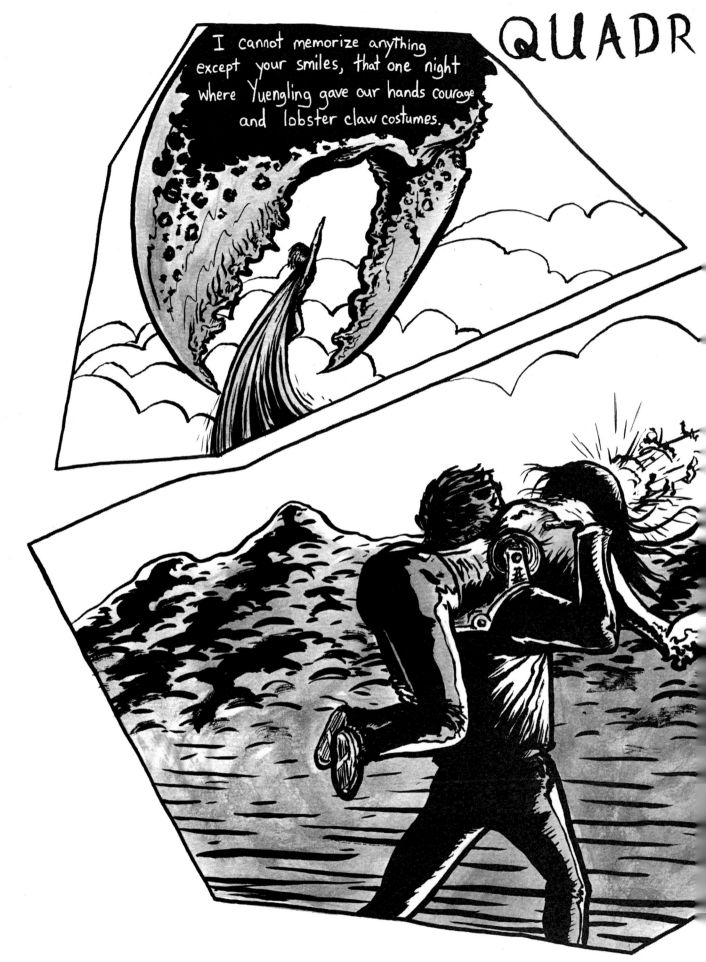

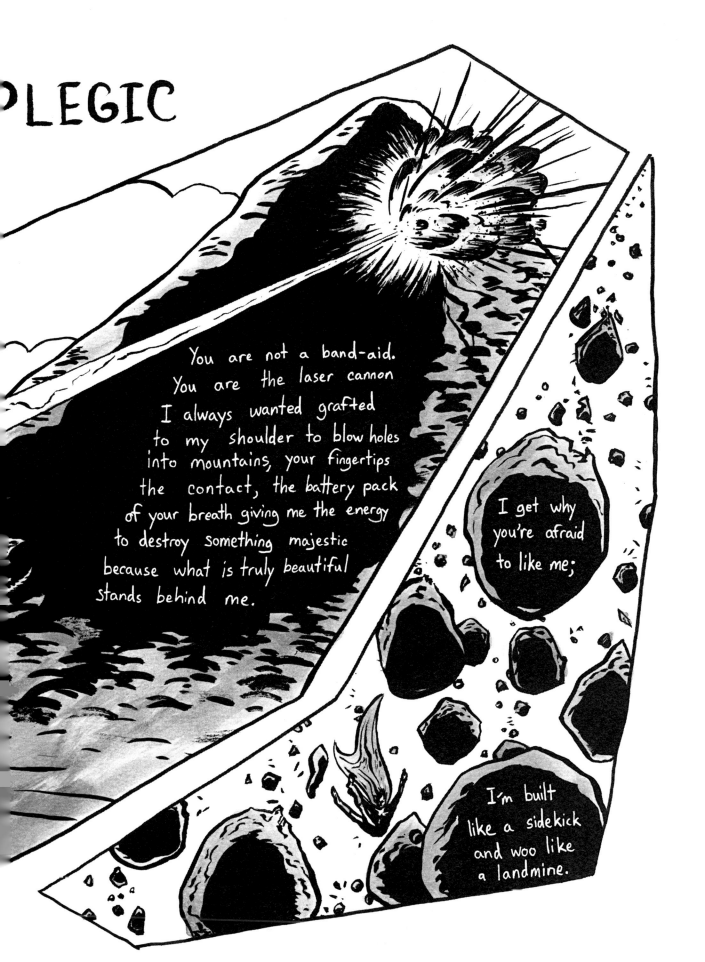

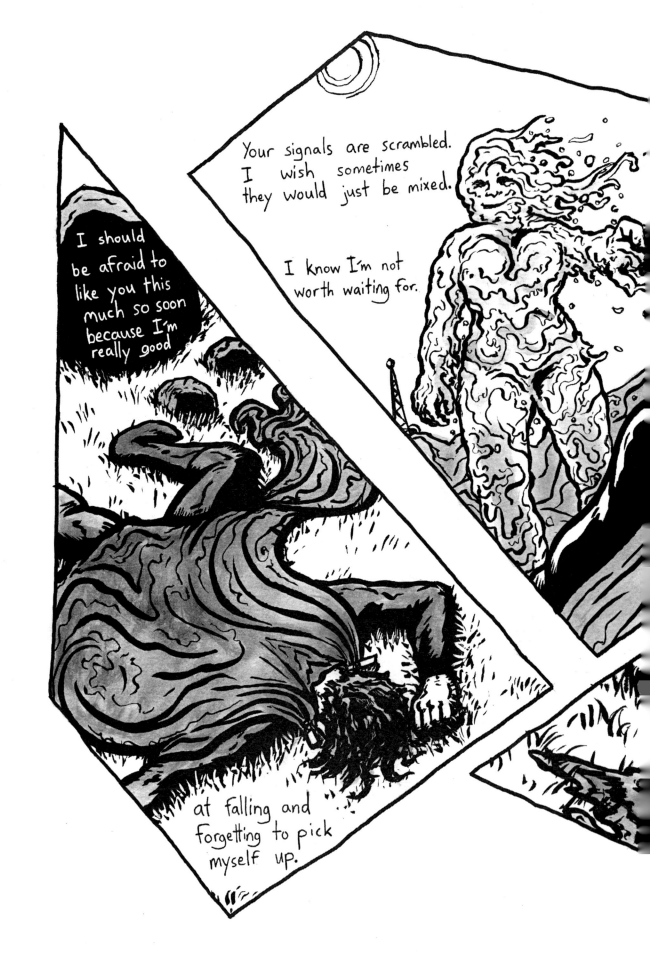

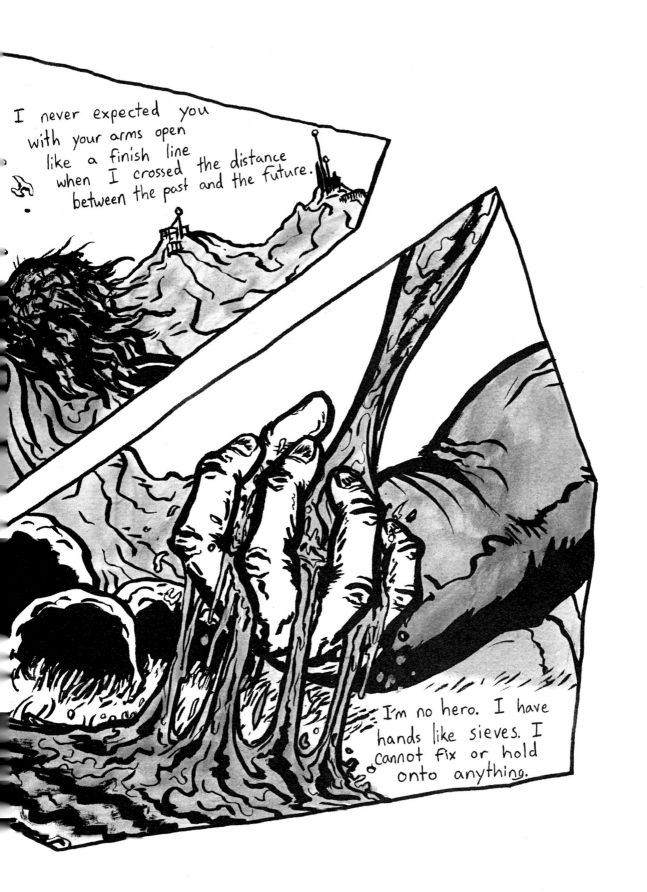

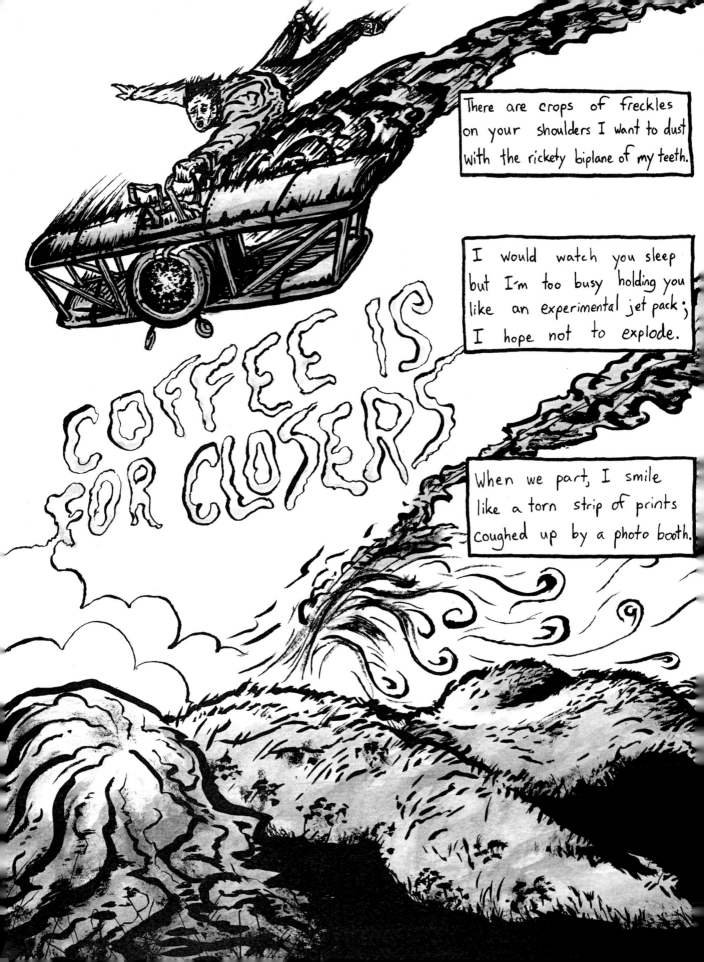

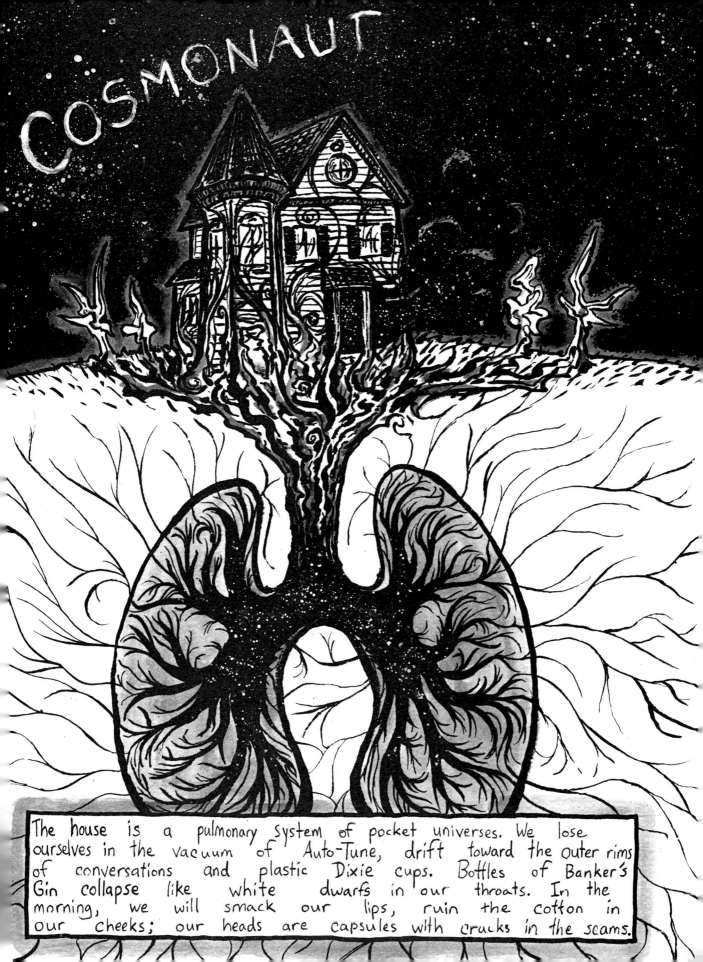

COSMONAUT

The house is a pulmonary system of pocket universes. We lose ourselves in the vacuum of Auto-Tune, drift toward the outer rims of conversations and plastic Dixie cups. Bottles of Banker's Gin collapse like white dwarfs in our throats. In the morning, we will smack our lips, ruin the cotton in our cheeks; our heads are capsules with cracks in the seams.

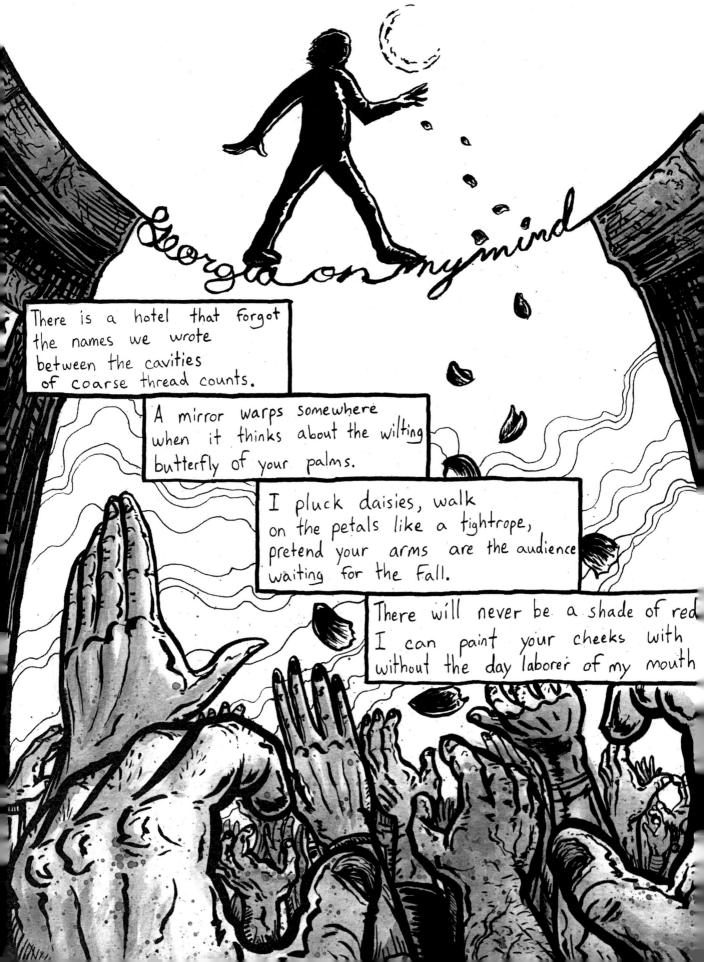

Georgia on my mind

There is a hotel that forgot
the names we wrote
between the cavities
of coarse thread counts.

A mirror warps somewhere
when it thinks about the wilting
butterfly of your palms.

I pluck daisies, walk
on the petals like a tightrope,
pretend your arms are the audience
waiting for the Fall.

There will never be a shade of red
I can paint your cheeks with
without the day laborer of my mouth

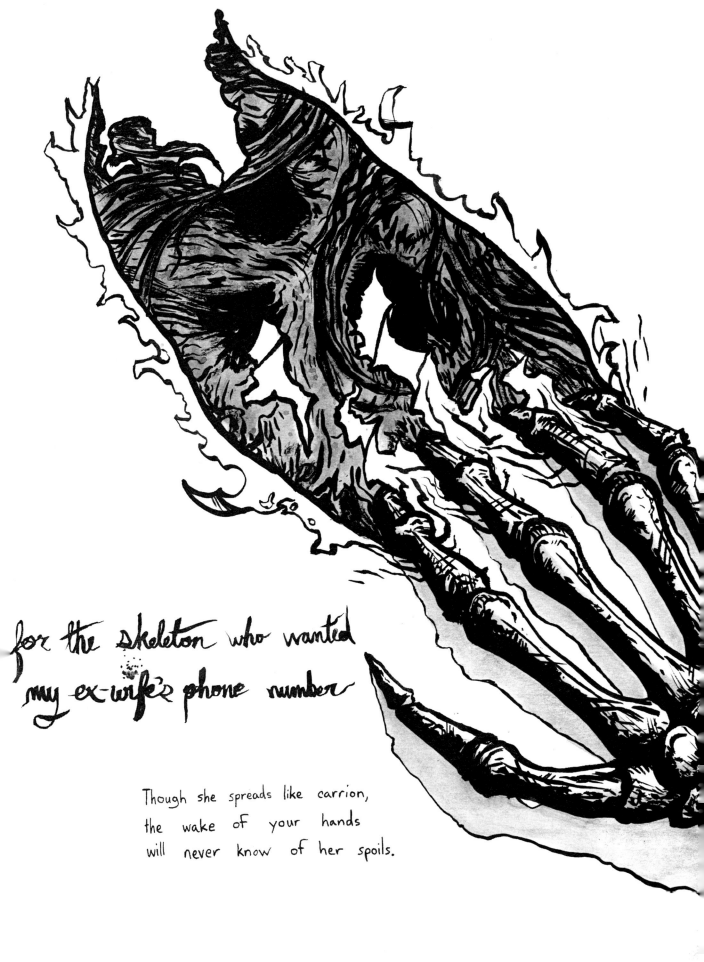

for the skeleton who wanted
my ex-wife's phone number

Though she spreads like carrion,
the wake of your hands
will never know of her spoils.

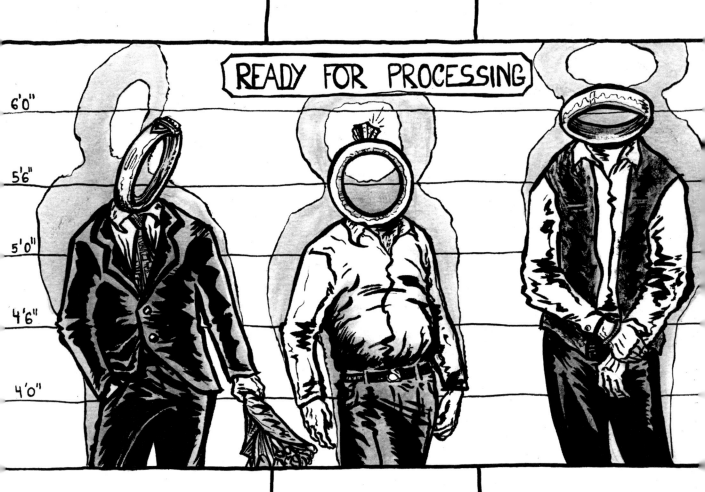

I let my mother do all the talking as the engagement ring/wedding band set spills out of the box and into the jeweler's hand. I'm sorry it didn't work out, he says. I couldn't make eye contact with him until he asks how much I expect to make from the set. My mother balks a little when I ask for half of what I paid. We talk about the consignment arrangement, collection details, cellphone numbers to call when it happens.

I look at the other jewelry in the consignment section as he enters the ring into the system with the other prisoners. The foreclosures, pointing fingers, the funds for a fuck-you bender. It makes me a little sick to see my artifact of failure take its place in the glass case. I hope the next woman's finger doesn't wither, her relationship doesn't spiral like October leaves.

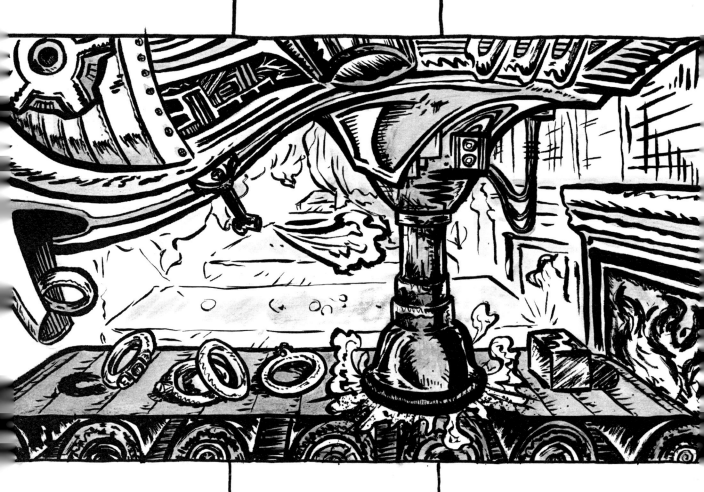

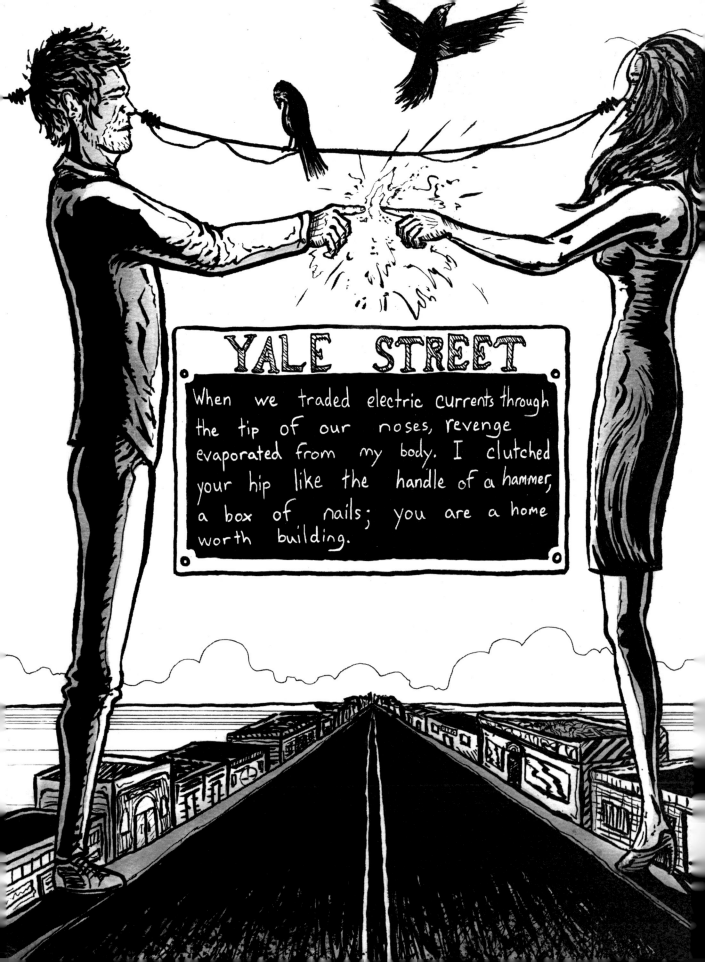

YALE STREET

When we traded electric currents through the tip of our noses, revenge evaporated from my body. I clutched your hip like the handle of a hammer, a box of nails; you are a home worth building.

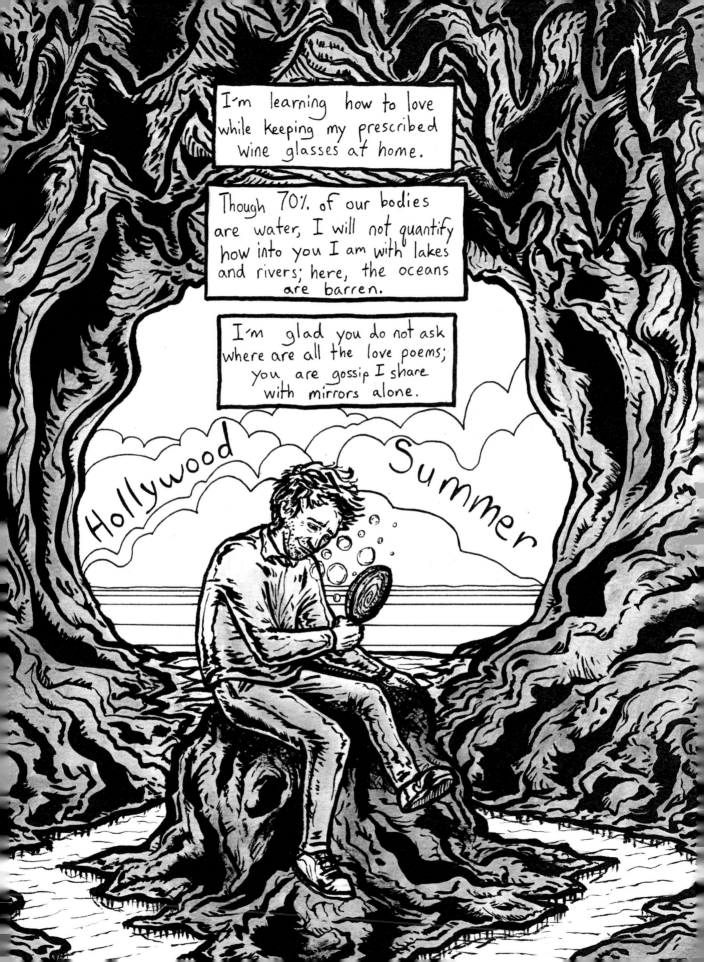

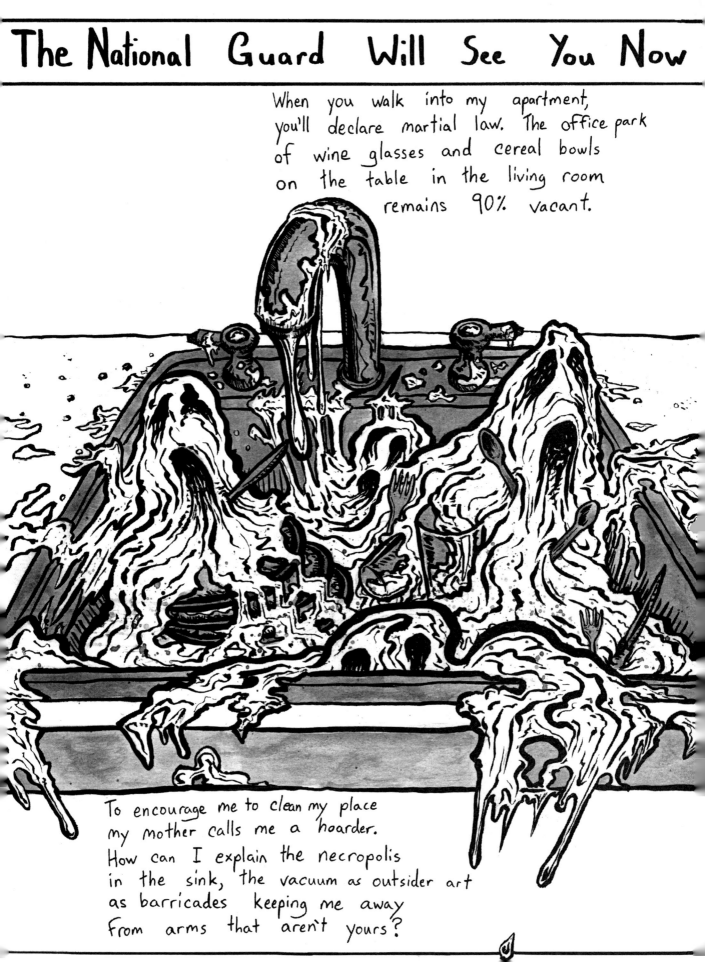

When you walk into my apartment,
you'll declare martial law. The office park
of wine glasses and cereal bowls
on the table in the living room
remains 90% vacant.

To encourage me to clean my place
my mother calls me a hoarder.
How can I explain the necropolis
in the sink, the vacuum as outsider art
as barricades keeping me away
from arms that aren't yours?

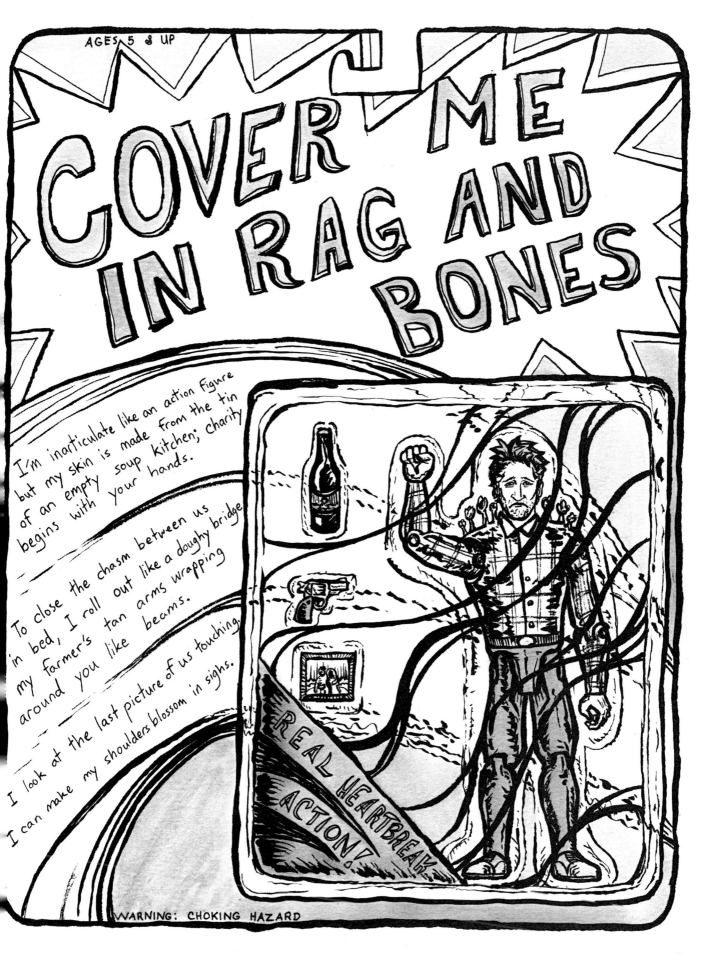

COVER ME IN RAG AND BONES

I'm inarticulate like an action figure but my skin is made from the tin of an empty soup kitchen; charity begins with your hands.

To close the chasm between us in bed, I roll out like a doughy bridge my farmer's tan arms wrapping around you like beams.

I look at the last picture of us touching I can make my shoulders blossom in sighs.

REAL HEARTBREAK ACTION!

WARNING: CHOKING HAZARD

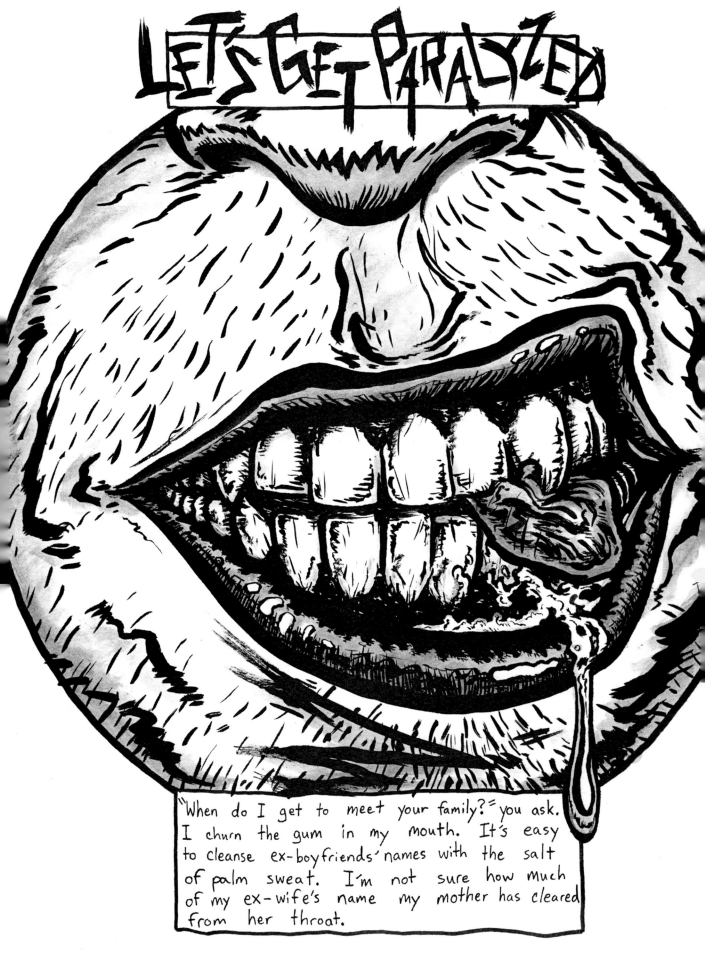

LET'S GET PARALYZED

"When do I get to meet your family?" you ask. I churn the gum in my mouth. It's easy to cleanse ex-boyfriends' names with the salt of palm sweat. I'm not sure how much of my ex-wife's name my mother has cleared from her throat.

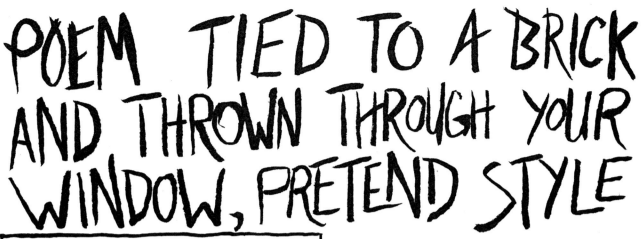

POEM TIED TO A BRICK AND THROWN THROUGH YOUR WINDOW, PRETEND STYLE

The urge to make you a card with an owl on a bough saying "I swooo ooo ooon over you" never came.

There would be stick figures with glasses, clothes hanging off our crooked limbs, awkward pipe cleaner fingers entwined; you would turn the page for the x-rated version.

I cannot draw our future, only hope there are no erasers around.

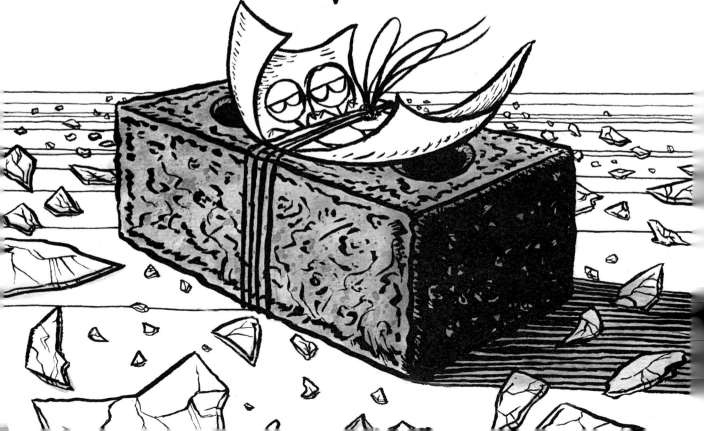

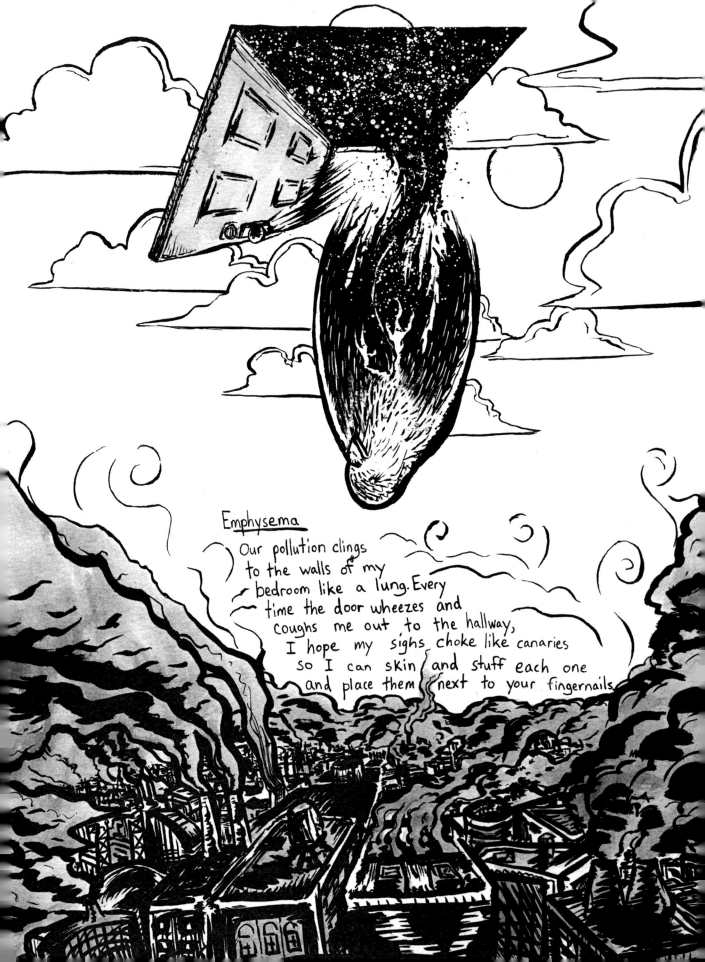

Emphysema

Our pollution clings
to the walls of my
bedroom like a lung. Every
time the door wheezes and
coughs me out to the hallway,
I hope my sighs choke like canaries
so I can skin and stuff each one
and place them next to your fingernails.

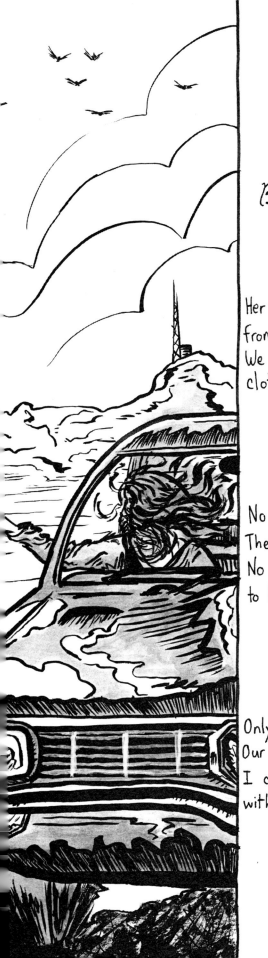
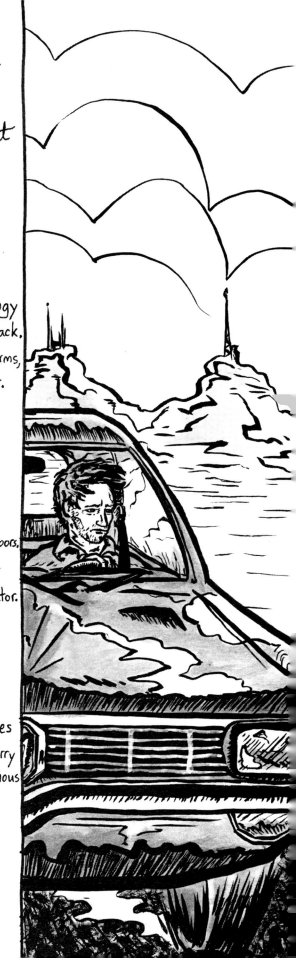

The Monogamist Experiences His first Amicable Breakup

Her fingers deliver the eulogy
from the small of my back.
We gather our mouths, arms,
clothes remain intact.

No police watch.
The furniture stays indoors.
No signed document
to hang on the refrigerator.

Only the armrest divides
Our last car ride. I'm sorry
I couldn't be synonymous
with home.

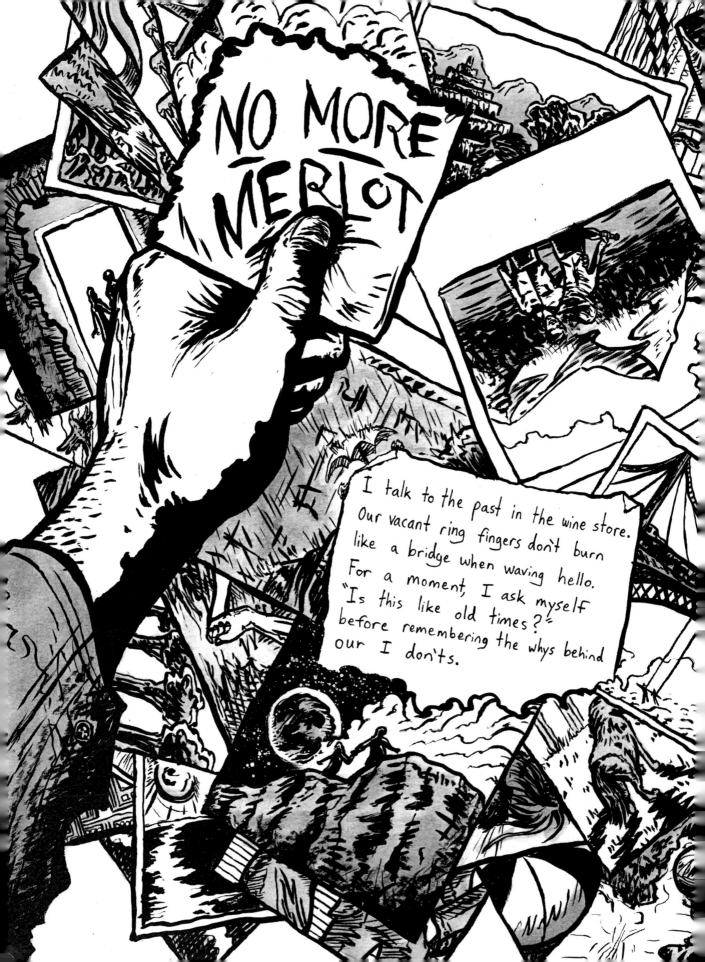

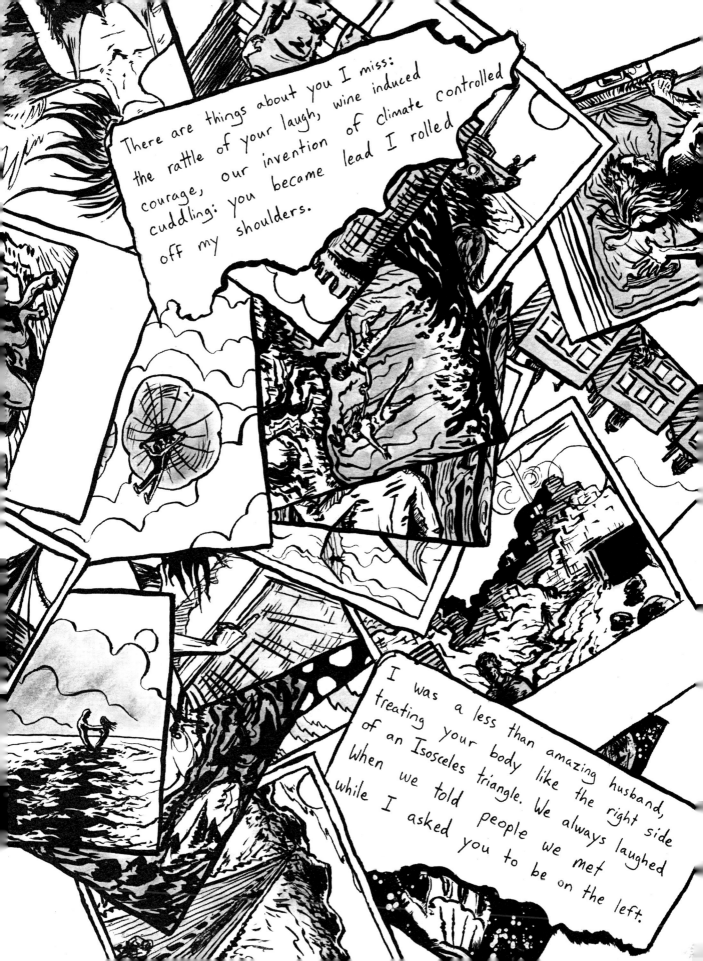

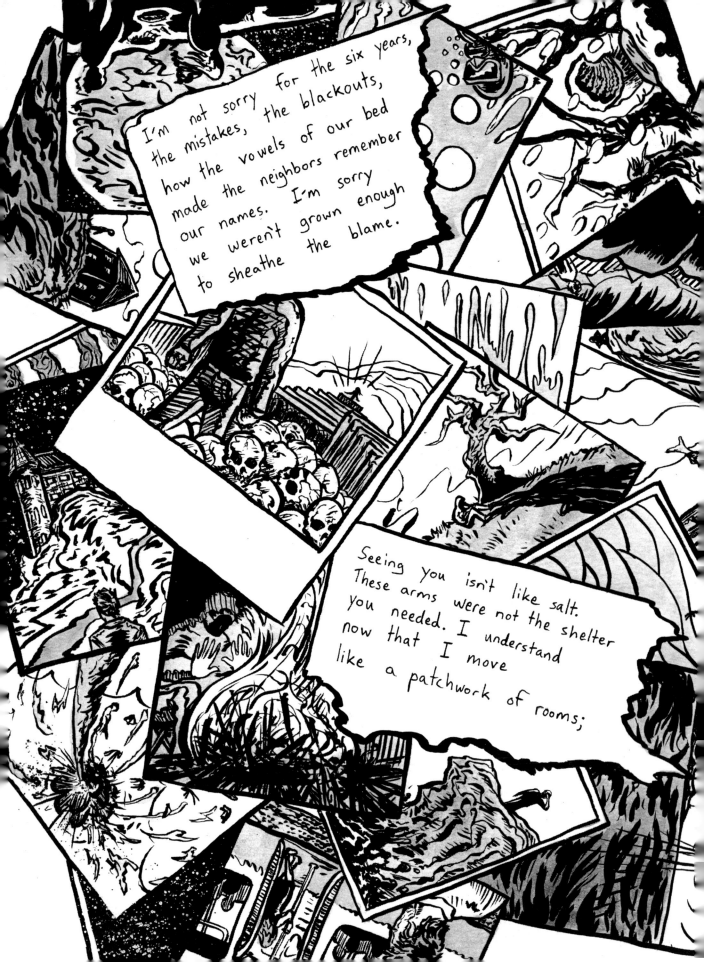

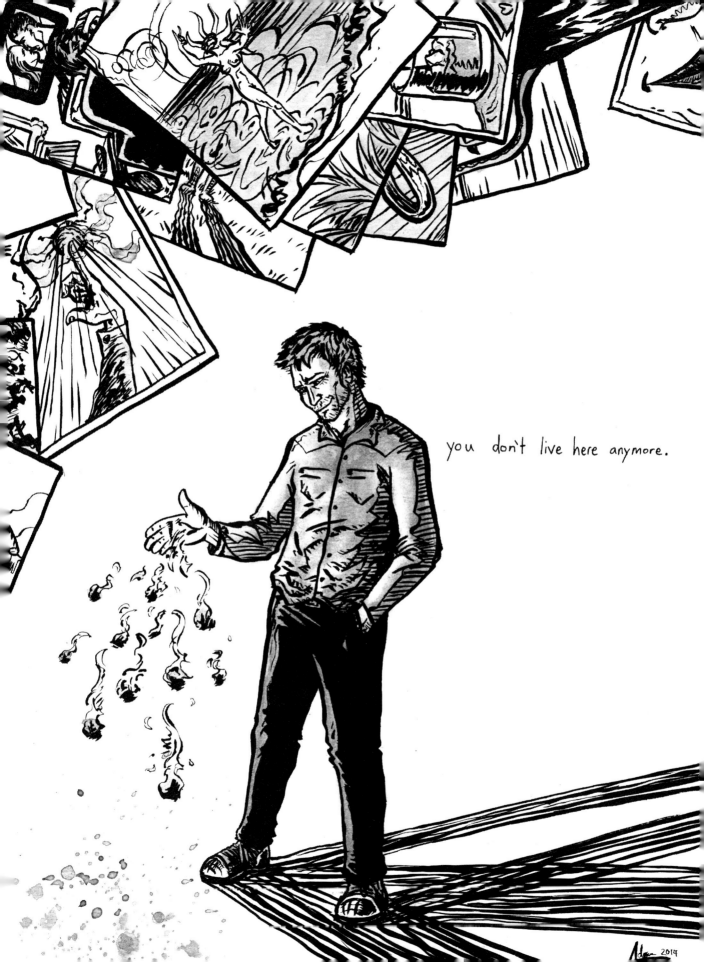

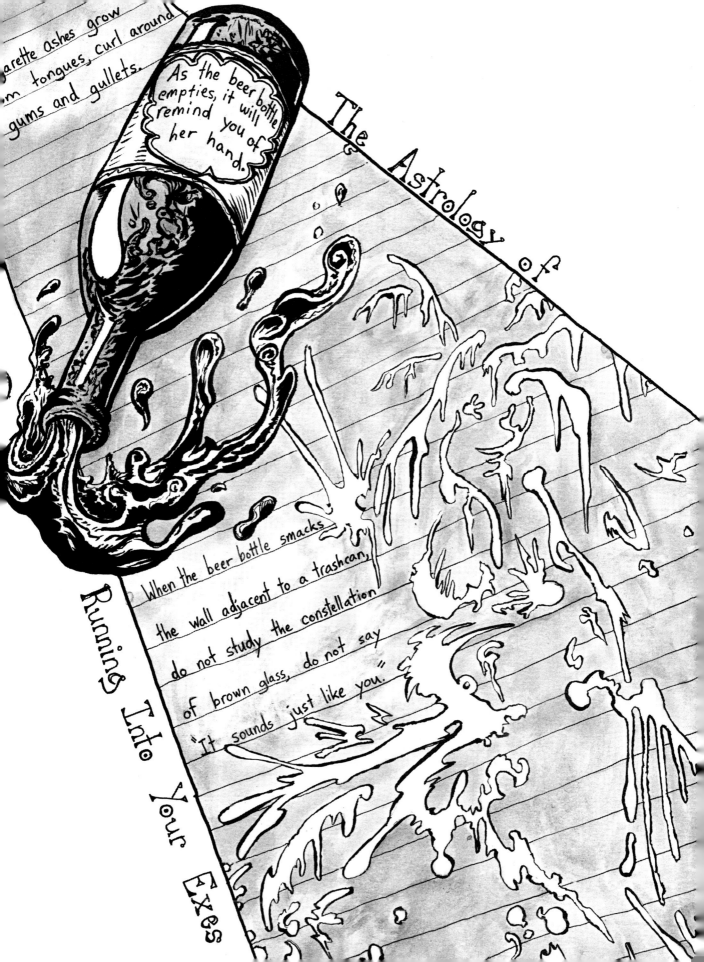

Thank you to the following literary magazines for publishing pieces from this collection in their current or a previous form: *3:AM Magazine, Bestiary Magazine, Camroc Press Review, Connotation Press, Dark Sky Magazine, Deuce Coupe, DOGZPLOT, The Florida Review, Girls with Insurance, The Legendary, Metazen, MiCrow, The Molotov Cocktail, [PANK], PicFic, Poets and Writers, Prick of the Spindle, The Scrambler, Short, Fast, and Deadly, Softblow, Vinyl Poetry.*

photo credit: Laura Cole

J. Bradley is a writer based out of Orlando, FL. He runs the Central Florida prose reading series/chapbook publisher There Will Be Words and lives at iheartfailure.net.

Thank you to Jason Cook, Matt DeBenedictis, Chad Redden, Roxane Gay, and M. Bartley Siegel for bringing me into this beautiful world of indie literature as an editor and/or as an author, and to my mom for enabling my poetry habit.

The biggest thank yous go to KMA Sullivan for her vision regarding this manuscript and to Adam Scott Mazer for his brilliance in turning these words into something amazing.

photo credit: Evan William Smith

Adam Scott Mazer is a Brooklyn-based illustrator, theater artist, and bon vivant. In 2011, he co-founded AntiMatter Collective, which has produced three of his original plays: *Death Valley*, *Motherboard*, and *The Tower*. *The Bones Of Us* is his first book. AdamScottMazer.com

Thank you to J. Bradley, KMA Sullivan, Dolan Morgan, Natalie Eilbert, Maya Rook, Danny Clark, Tim Spinosi for teaching me everything I know about drawing, and especially Michael and Carole Mazer for not laughing in my face when I was eight years old and I told them I wanted to be an artist.

The Bones of Us, a fully illustrated graphic poetry collection with words by J. Bradley and art by Adam Scott Mazer, has been more than two years in the making. When J. Bradley sent me his manuscript, I was intrigued by the vivid language and poignant narrative contained in the collection. As I read and reread the manuscript, it was clear to me that the book needed to live as an illustrated collection. The hunt for an artist began. We had been looking for months for the right pen & ink artist when Dolan Morgan, a fiction writer, sent me a story of his that had been illustrated by a number of different artists. One of the artists was Adam Scott Mazer. Adam's work was powerful and raw. I sent samples to J. who immediately agreed that it was a perfect match for the project.

But how to fund such a project? Even though most small presses, including YesYes Books, run on a volunteer editorial staff, money is tremendously tight. Indeed, over the past couple of years we've seen some well-loved presses fold due to the difficult financial environment for poetry. *The Bones of Us* is an experimental project. Not since Blake has a full-length poetry collection been released first as an illustrated collection. The physical production would be expensive. How could YesYes embark on such a project without endangering the other books that we had already committed to publishing? On July 1 2013 YesYes Books opened its first Kickstarter Campaign. One month later, thanks to 138 backers, *The Bones of Us* was fully funded. In fact, we raised 108% of our goal. We are blessed to be part of an art community that so readily comes forward to support projects that push the boundaries.

YesYes Books offers heartfelt thanks to all those who contributed to our Kickstarter Campaign and in particular to Patricia Aiken, William Aiken, Mark Derks, Cynthia Duby, Luke Goebel, Myung L. Kim, Jessica Maybury, J.B. Mazer, Carole Mazer, Eddie Selover, Charles Sullivan, and Dan Sullivan. As always, a gratitude without end go to the amazing and selfless editors and designers at YesYes Books and *Vinyl Poetry* including Tory Adkisson, JoAnn Balingit, Heather Brown, Stephen Danos, Mark Derks, Stevie Edwards, Raina Fields, Alban Fischer, Jill Kolongowski, Thomas Patrick Levy, Rob MacDonald, John Mortara, Amber Rambharose, and Phillip B. Williams.

The largest thanks for the life of *The Bones of Us* go to the incredibly talented J. Bradley and Adam Scott Mazer. It has been sheer pleasure to work with you both.

Rock on and make art!

-KMA Sullivan
Publisher, YesYes Books

POETRY BY J. BRADLEY
ART BY ADAM SCOTT MAZER
EDITED BY KMA SULLIVAN

FIRST EDITION, 2014
ISBN 978-1-936919-27-7
PRINTED IN THE UNITED STATES OF AMERICA

PUBLISHED BY YESYES BOOKS
1232 NE PRESCOTT STREET
PORTLAND, OR 97211
YESYESBOOKS.COM

KMA SULLIVAN, PUBLISHER
JILL KOLONGOWSKI, MANAGING EDITOR
JOHN MORTARA, SOCIAL MEDIA EDITOR
ROB MACDONALD, DIRECTOR OF EDUCATIONAL OUTREACH
HEATHER BROWN, ASSISTANT MANAGING EDITOR
TORY ADKISSON, ASSISTANT EDITOR
JOANN BALINGIT, ASSISTANT EDITOR
STEVIE EDWARDS, ASSISTANT EDITOR
RAINA FIELDS, ASSISTANT EDITOR
AMBER RAMBHAROSE, ASSISTANT EDITOR
STEPHEN DANOS, EDITOR-AT-LARGE
MARK DERKS, FICTION EDITOR, *VINYL POETRY*
PHILLIP B. WILLIAMS, POETRY EDITOR, *VINYL POETRY*
ALBAN FISCHER, GRAPHIC DESIGNER
THOMAS PATRICK LEVY, WEBSITE DESIGN AND DEVELOPMENT

ALSO FROM YESYES BOOKS

If I Should Say I Have Hope by Lynn Melnick

Boyishly by Tanya Olson

The Youngest Butcher in Illinois by Robert Ostrom

I Don't Mind If You're Feeling Alone by Thomas Patrick Levy

American Barricade by Danniel Schoonebeek

Panic Attack, USA by Nate Slawson

Man vs Sky by Corey Zeller

Frequencies: A Chapbook and Music Anthology, Volume 1
[SPEAKING AMERICAN BY BOB HICOK, LOST JULY BY MOLLY GAUDRY, AND
BURN BY PHILLIP B. WILLIAMS PLUS DOWNLOADABLE MUSIC FILES
FROM SHARON VAN ETTEN, HERE WE GO MAGIC, AND OUTLANDS]

VINYL 45s
A PRINT CHAPBOOK SERIES

Pepper Girl by Jonterri Gadson

Bad Star by Rebecca Hazelton

Still, the Shore by Keith Leonard

Please Don't Leave Me Scarlett Johansson by Thomas Patrick Levy

No by Ocean Vuong

POETRY SHOTS
A DIGITAL CHAPBOOK SERIES

The Blue Teratorn by Dorothea Lasky
[ART BY KAORI MITSUSHIMA]

Toward What Is Awful by Dana Guthrie Martin
[ART BY GHANGBIN KIM]

My Hologram Chamber Is Surrounded by Miles of Snow by Ben Mirov
[IMAGES BY ERIC AMLING]

Nocturne Trio by Metta Sáma
[ART BY MIHRET DAWIT]

How to Survive a Hotel Fire by Angela Veronica Wong
[ART BY MEGAN LAUREL]